BEASTLY
GLASGOW

Barclay Price

AMBERLEY

I'm not an animal lover if that means you think things are nice
if you can pat them, but I am intoxicated by animals.

Sir David Attenborough

First published 2022

Amberley Publishing
The Hill, Stroud
Gloucestershire, GL5 4EP

www.amberley-books.com

Copyright © Barclay Price, 2022

The right of Barclay Price to be identified as the
Author of this work has been asserted in accordance
with the Copyrights, Designs and Patents Act 1988.

ISBN 978 1 3981 1341 1 (print)
ISBN 978 1 3981 1342 8 (ebook)

British Library Cataloguing in Publication Data.
A catalogue record for this book is available from the
British Library.

Typesetting by SJmagic DESIGN SERVICES, India.
Printed in Great Britain.

Contents

Introduction

The house in which I grew up was part of what had been large stables in Glasgow's West End built by my great-grandfather. Although by my time the business had become a garage, old horse stalls remained in the unused first-floor lofts as a reminder of how central horses had been in Glasgow's development. As a child I saw animals performing in the circus and on stage, and visited Calderpark Zoo, yet today few animals are to be seen in the city. This book explores Glasgow's history with animals, including a famous pig, a political lion tamer, inquisitive elephants and a fox that sought footballing fame. As the final chapter relates, there still are exotic animals to be seen around the city, portrayed in its public spaces.

Barclay Price

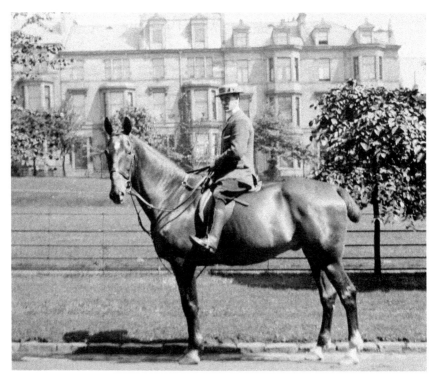

My grandfather, James Barclay Price, on horseback in Athole Gardens, Glasgow, *c.* 1910.

1. Horse Power

Glasgow's population was around 12,000 in 1707 when Daniel Defoe visited and described the city as 'the cleanest and beautifullest, and best built city in Britain, London excepted'. That changed through the nineteenth century as the city's industrial expansion took its population to around one million by 1900 – many living in slums. The initial growth came from international trade to and from the Americas, especially sugar, tobacco, slaves, cotton, and manufactured goods, and later by heavy engineering and other industries. Central to the city's enlargement were the horses that moved goods and people in and out of the city, and their sight, sound and smell were an integral part of the city's life well into the 1950s. There were four broad types of horses: saddle horses, ridden by an individual and by the cavalry; carriage and coach horses; cart and pack horses; and farm horses, mainly used in ploughing.

In the eighteenth century many of the Glasgow's 'tobacco lords' and other well-off inhabitants owned houses in both the city and nearby countryside. Up until the second

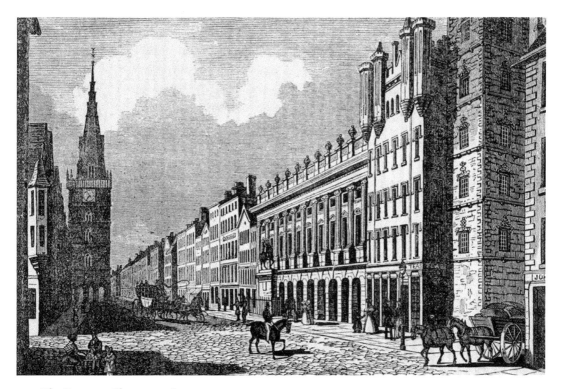

The Trongate, Glasgow, c. 1830.

half of the century those that commuted between the two would have ridden a saddle horse, as it was not until 1752 that the first personal carriage was seen in the city. This belonged to Allan Dreghorn, a timber merchant, who had it made by his carpenters. As there were no pavements and the ground was dirty, well-to-do people often travelled around the city in sedan chairs. These were a leather-covered box carried on two poles by two footmen. By the 1840s these had been replaced by small carriages. William Moses made his fortune from selling sedan chairs but when he travelled the 2 miles from his country mansion at Mosesfield into the city in the 1790s he would have ridden on horseback or travelled by a horse-drawn carriage. Coincidentally, it was in Mosesfield that one of the earliest signs that horse transport would eventually disappear was seen, for there in October 1895 George Johnston, a minister's son, built the first motor car ever produced in Scotland.

The 1788 records for horse tax payments – a tax introduced a few years earlier to help pay for the war against France – listed around 230 horse owners in the city, the great majority of whom owned just one horse. Although some women rode horses, for young wives who spent many years pregnant or recovering from childbirth, and older women, a carriage was essential. These mainly were two person vehicles pulled by one or two horses. Miss Pollock, the owner of Pollock Castle, 10 miles from the centre, is recorded as keeping two horses at her city house in Reid's Land (the east end of Argyle Street).

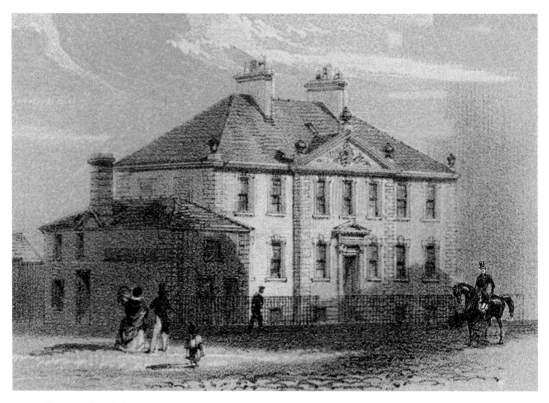

Allan Dreghorn's house in Great Clyde Street.

A post-chaise carriage.

James Buchanan, owner of the Saracen's Head Inn, paid tax on six horses. Some may have been horses he rented out as he advertised a 'post-chaise' – an enclosed coach carrying two passengers – for hire with a driver. His inn advertised 'Beds are all very good, clean, and free from bugs. There are very good stables for horses, and a Pump-Well in the yard for watering them, with a shade for coaches, chaises, and other wheel carriages'. The first stagecoach service between Glasgow and Edinburgh was instituted in 1678 by 'ane sufficient strong coach, to be drawn by six able horses, to leave Edinbro ilk Monday morning, and return again (God willing) ilk Saturday nigh', but stopped after about five years. It was not until the mid-1700s that a service was reintroduced. The 'Glasgow Fly' coach service to Edinburgh operated from the Saracen's Head and by 1760 ran every day except Sunday. It was drawn by four horses and carried four passengers. Fresh horses were supplied at Whitburn and passengers took breakfast there while the weary horses enjoyed water and hay. By 1800, and until the opening of the railway, twelve stagecoaches made a daily run between the cities. There were a variety of formats for the Glasgow to Edinburgh services. Some were drawn by four horses with two changes for fresh horses, while another was a smaller coach drawn by two horses that were changed six times, thus reducing the journey time to four hours.

In 1788 the first London to Glasgow mail coach service began. By then there also was a passenger service to England that operated from the Saracen's Head Inn: 'By the direct road through Moffat, Lockerbie, and Ecclefechan, for Carlisle; and it is connected with the London and other stages from Carlisle to the different great cities and public places in England. The communication is very quick; the passengers go from Glasgow to London in four days.' Additional routes operated from other inns in the city, such as ones for Greenock and Dumbarton that ran from the Black Bull Inn in Trongate where stabling for forty horses was available.

It was important for horses to be regularly exercised as those that were stabled on their own or not regularly exercised often became fractious. Some developed bad habits such as kicking the walls of the stall with the hind feet or biting on the feeding box. Horses that were content in their stable often came to know the way home and it was not unknown

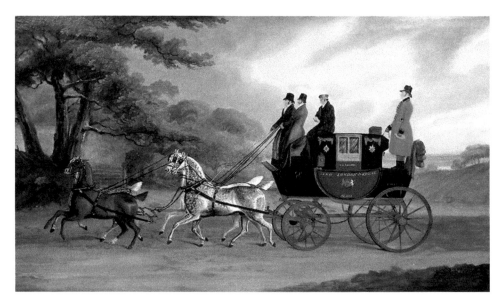

The Glasgow to London mail coach by artist Benjamin Herring.

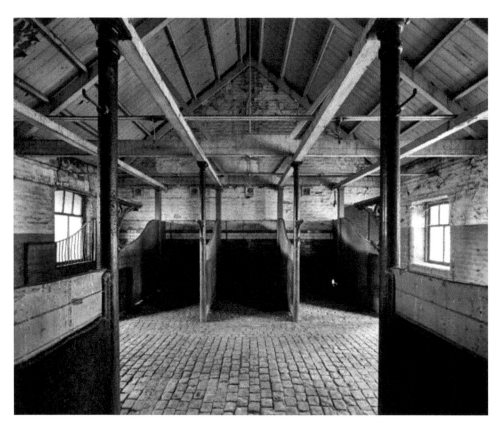

Horse stalls at Bell Street stables in Merchant City that housed the city's police horses and those that pulled the city's refuse collection carts.

for a rider to doze off, leaving the horse to navigate the way back. The opposite was also the case. When the Bishop of Glasgow travelled by saddle horse he was followed at a respectful distance by his servant: 'His servant's horse had a trick of sleeping on the way, and, when he roused up, invariably threw his rider and the Bishop had to dismount to gather his servant up and adjust his appurtenances anew.'

In the 1780s John Baird of Craigton, a keen huntsman and horse racer, lived in a large mansion in what is now Brunswick Street and its large garden included 'A leaping Bar, encircled with furze and thorns, about 4 feet high, over which he trained his young hunting horses to leap. Also, extending its whole length of the garden was a broadway, all laid down with tan bark, which made a pleasant soft path for giving his horses exercise upon. In these days here, daily, might have been seen Mr. Baird's jockeys trying his horses in all their paces.' As Glasgow did not have a racecourse, John Baird and others who owned racehorses would have run them at various courses, including Lanark, the site of Britain's oldest horse race, the Lanark Silver Bell. It was not only the wealthy who indulged in horse racing. Informal races by cart horses often took place and even by the 1950s horses that normally pulled milk carts were raced in Garscube Road on quiet Sunday mornings.

In the 1790s, when Britain was at war with France, many feared a French invasion and so volunteer forces formed. Among many created in Glasgow was the Royal Glasgow Volunteer Light Horse. Its members had to own a horse and pay for their own uniforms, and so the sixty-strong regiment consisted of the wealthier residents. The commander was John Orr, an advocate. Although Orr had been a first-rate horseman in his younger days, by this time 'his gout prevented his being very agile at a rapid charge of the troop, or at the Austrian sword exercise'. None of the volunteer units were called into action and for many it was the 'peacock splendour' of the uniforms and the social aspect that drew them to volunteering rather than any real impulse to defend Glasgow should the French invade.

Around this time the eccentric Doctor Marshall took it into his head to see whether he or his horse could hold out longest upon a minimum of food. Each day he ate just one raisin and allowed his horse one piece of straw. After a time, unsurprisingly, the horse died and the doctor lost the power of his left side. He also lost his patients, who not unreasonably wondered what mad experiment the doctor might try on them.

In 1821 cavalry barracks were built across the river in the Gorbals (Eglinton Street). In 1838 the 15th King's Own Hussars were dispatched to the barracks in response to fears that growing radical protest in Glasgow might erupt into revolt. The regiment had fought with distinction at the Battle of Waterloo, as commemorated on one of the plaques on the Duke of Wellington statue in Royal Exchange Square. Perhaps the wealthy English soldiers became bored as the feared revolt did not arise and so sought alternative excitements. A wager was made that Lieutenant Knox could not ride from the barracks across the river and through the recently opened fashionable Argyll Arcade within five minutes. Knox did not flinch from the challenge. Fully kitted out with lance and sabre, he galloped out of the barracks, across the river and charged into the narrow arcade, scattering shrieking fashionable ladies in his wake. While he won his bet, the great and the good of Glasgow were unamused. Knox was fined £5 and the regiment was ordered to leave Glasgow for Madras.

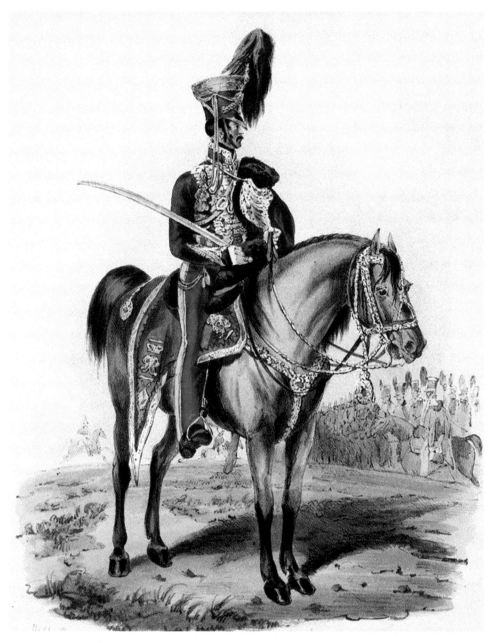

A cavalry officer of the 15th Hussars.

Although no one needed to take a test to ride a horse, riders needed to gain experience in judging their mount's mood. As horses respond strongly to other horses and communicate through body language, riders understanding these signals could save themselves an unforeseen movement that might unseat them. Yet there were many who rode recklessly, leading to 'hit and run' incidents: 'A little girl was amusing herself along

with a number of her companions on the Pollockshaws Road when she was thrown down by two equestrians who rode forward at such a furious pace that it was impossible for her to get out of the way in sufficient time. Though the poor child was seriously injured by the horses' hooves, the parties, who in external appearance were gentlemen, unfeelingly and recklessly rode on without paying the slightest attention, or rendering the least assistance to the sufferer.' Servants and stable-boys who took their owners horses to the countryside for exercise were often the cause of complaints: 'The inhabitants of Finnieston request of those gentlemen who send their horses to the fields for exercise, that they will desire their servants not to ride through the village in such crowds, and at such speed, as has been done for some time past. The bleachfields, from the quantities of dust dispersed by the horses, are almost ruined, and the lives of the inhabitants, from the number and fury of the riders, have been often in danger.'

Pedestrians, especially children, were always at risk from being knocked down by riders, carriages and carts, and women who rode alone were at risk from barracking children: 'I allude to the foolish and dangerous custom of children screaming out to and following lady equestrians Whenever a lady on horseback is observed groups of children congregate; and not content with trying their best to frighten the horse by yelling at the tops of their voices they frequently dance out in front of the horse's feet, thereby endangering their lives, and, I need scarcely say, exciting the horse so much by their

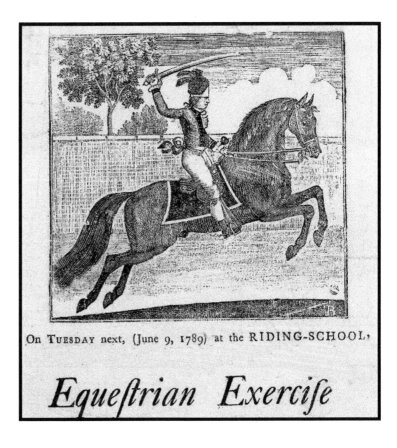

On TUESDAY next, (June 9, 1789) at the RIDING-SCHOOL,

Equeſtrian Exerciſe

Riding School
exercise, 1789.

deafening hubbub that a fatal accident to the rider might be the consequence. By the above-mentioned foolish custom, riding by ladies is rendered highly unpleasant.'

To help improve the quality of riding, the Light Horse volunteers raised funds to build the city's first Riding School in York Street. It opened in 1798, and had two exercising circles of 40 feet each and a gallery for spectators. The school offered instruction in equestrian skills, the breaking in of horses, and also hosted displays of proficient riding. In 1838 the riding school moved to a larger building in Campbell Street and an additional service on offer was stallions to cover horses. In 1846 Benbow, winner of a race at Ayr, was on hand to service fillies.

By 1815 there were around 300 saddle and carriage horses in Glasgow. The great majority would have been well looked after as they were owned by the better-off and a good horse was an expensive investment. In that year tax was paid on around 400 cart horses. Again the majority of these would have been well cared for but the constant hauling of heavy loads took its toll. Life expectancy for many cart horses was as low as three years. In 1820 the great Clydesdale horse was bred for its strength and became particularly used in hauling heavy loads, but even such a strong horse might only last nine years given the relentless work expected of it.

Dredging of the River Clyde began in the 1770s but before that parts of the river were shallow enough to be crossed by horses and carts. There was one crossing in the centre of Glasgow called the 'Horse Ford' that connected the Broomielaw and the Gorbals. This was an easier route than across the only bridge at that time as it was humped and its incline so

View of Old Bridge from Clyde Street drawn and engraved by Joseph Swan, 1829.

steep that horses pulling heavy loads struggled to cross it. In 1648 the situation was made worse for the unfortunate horses as the council ordered carters to remove the wheels of their carts and instead to cross with the 'boddie of the cart alone drawn by the horse'. In 1772 a second Glasgow bridge was opened and, to the relief of horses, it was flat.

Horses were an essential part of Glasgow's rapid expansion. The building boom required vast amounts of stone and other materials to be hauled from nearby quarries or ships; raw materials had to be brought into the factories and the produced goods taken away; the growth of the suburbs meant coal, milk, food, furnishings, etc., had to be delivered farther afield; and horses conveyed the city's inhabitants. In 1855 John Strang recalled that in earlier times 'Every mercantile house in Glasgow doing country business, kept what is called their "rider" who made periodical journeys throughout Scotland on horseback. This practice arose from the general badness of the roads and the want of public communication between towns; and from this circumstance it is said riding became not only fashionable but useful.'

The earliest form of horse-drawn omnibus was the 'Caledonian Basket' that was introduced in the mid-1820s, although it was two decades before further city omnibus routes came into being. In 1847 a one-horse bus was introduced that ran from the city centre to the Botanic Garden to persuade people to move to the new West End developments. There was no standard format to the horse-drawn omnibuses and different combinations of horses were used. Glasgow was one of the first cities to develop a tram network and in 1872 the first horse-drawn tram ran between St George's Cross and Eglinton Toll. By 1890 the Glasgow Tramway and Omnibus Company owned around 3,500 horses, many of these imported. In Glasgow one day in the early 1890s Robert Cunninghame Graham, a Scottish politician and writer, who had been an adventurer in his younger days and spent time in South America 'sleeping upon a saddle under the southern stars, or galloping across the plains in the hot sun', happened to spot an Argentine stallion pulling a tramcar, and bought it from the Glasgow Tramway Company and rode it until its death in 1911.

The Glasgow 'Caledonian Basket' omnibus.

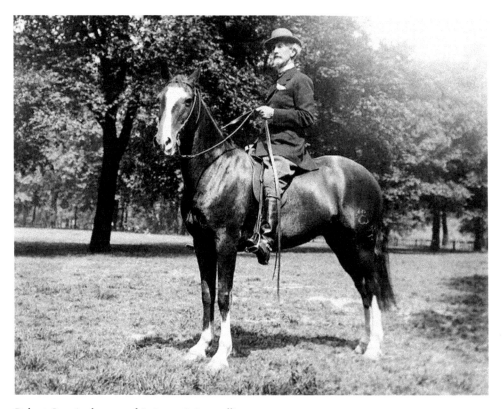

Robert Cunninghame on his Argentinian stallion.

The introduction of electric trams from 1898 brought an end to horse-drawn public transport, although private horse-drawn hackney coaches continued into the 1930s.

As well as suffering from constant hauling of heavy loads some cart horses were ill-treated. In 1865 three cases of cruelty to horses were heard in the Glasgow court. One carter whose horse was lame had been stopped by a concerned citizen and accused of maltreatment at which the carter galloped off by flogging the poor animal into action. He was later traced and found guilty. The other two cases involved men beating their horses. Others appeared charged with being drunk while in charge of horse-drawn carts and accidents often occurred due to such inebriated drivers, and it was more often the horses that came off worse.

The expanding population of horses led to a rise in those employed in related trades, such as saddlers, harness makers, grooms, fodder suppliers, horse trainers, horse dealers and farriers. By the 1880s Glasgow had around 200 blacksmiths to shoe horses. Many of Glasgow's wealthy mercantile and professional class moved to the new houses being built in the West End and large stables, such as the one built by Thomas Price off Byres Road in 1880, housed their carriages and horses. At Price's Stables the horses were kept on an upper floor reached by ramps. Stables such as this also sold horses on behalf of clients: 'Hunter for sale, 16 hands, 6 years old. Has been hunted two seasons in Ayrshire Renfrewshire, splendid fencer and fast: has been driven in single harness.'

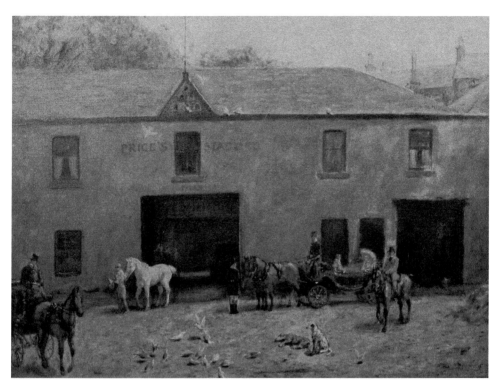

Price's Stables, Ruthven Lane, by unknown artist. (Author)

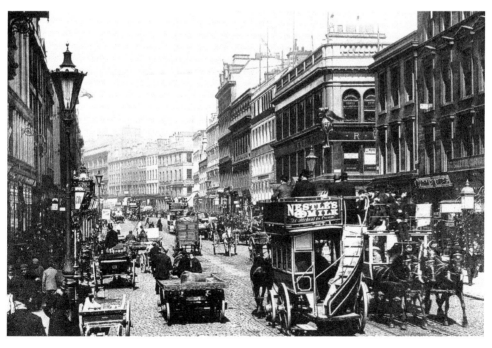

Jamaica Street, Glasgow, *c.* 1900. (BFI)

One concern arising from the expanding number of horse-drawn vehicles was raised in a *Times* article in 1894 entitled 'The Great Horse Manure Crisis'. The writer predicted that in fifty years every street in London would be buried under 9 feet of manure. By 1914 a quite different concern was raised in the *Daily Record* highlighting the conflict between horse-drawn vehicles and the growing number of motor vehicles:

> The slow traffic obstructs the fast, and the conglomeration of the two leads to frequent passing and repassing and a state of congestion … to those who are horrified at the number of street accidents in which motors arc concerned it is this mixture of traffic that is the cause of the danger, and as the motor-car certainly cannot be abolished the right thing to do is hasten, by every possible means, the day when slow horse traffic will debarred from the use of city streets.

It did not require any policy of prohibiting horse-drawn vehicles to force the horse off the road. The horse disappeared from the streets as the use of cars and other motorised vehicles increased, and Price's Stables became Price's Garage. However, the significant poverty in Glasgow meant that horse-drawn vehicles lingered on longer than in many other parts of Britain and some could still be regularly seen into the 1960s. Today the only horse one is likely to encounter in the city is a police horse, although recreational horse riding thrives on the outskirts and in the nearby countryside.

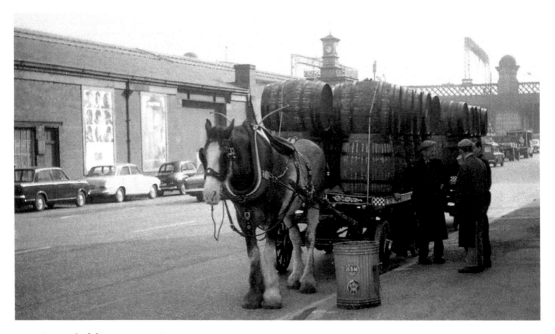

Brewer's delivery cart, 1960s.

2. Equestrian Events

For centuries trick riding on horses was a popular act at local fairs. Such acts often were performed in a temporary circular arena, as this allowed a larger audience to watch and enabled the rider to use centrifugal force to keep their balance while standing on the back of the galloping horse. One of the most skilled trick riders of his day was Philip Astley, and in 1768 he and his wife opened a Riding School in London. There Philip taught horsemanship in the morning and in the afternoon performed equestrian tricks for a paying audience. That same year Philip introduced a clown act

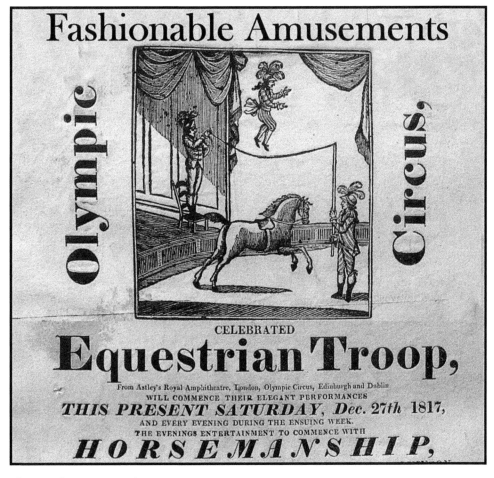

Olympic Theatre poster, 1817.

in a short play called *Tailor's Ride to Brentford* and so is often credited as the 'father of modern circus'.

Although individual trick riders probably performed in Glasgow, one of the earliest equestrian troupes to appear in the city was the touring Olympic Circus that performed in Ingram Street in March 1804. Its programme promised 'extraordinary horsemanship' and included Master Davis on his horse 'circling the hall at great speed and leaping through two balloons', and Mr Crossman making 'a surprising leap over four boards nine foot high, the horse at full speed'. From 1805 to 1825 the Caledonian Theatre in Dunlop Street was the main venue for equestrian entertainments. It had a stage and a circus ring as many of its programmes included theatrical plays and dances, as well as equestrian acts. In 1812 one evening ended with a pony race: 'a commodious course, by means of platforms, combining the whole extent of the stage and equestrian circle, has been constructed and completely railed in, according the audience a perfect and safe view of the whole race by six real ponies!'

In early 1839 William Batty, a famous equestrian performer, brought his touring circus to Glasgow and it was housed in a large pavilion in Hope Street:

As to the displays of horsemanship we need only say, that they in general partook of grace and dramatic effect. Mr Powell showed great skill as the Caledonian horseman, and Mr Wilkinson as a sailor, although we think the portraiture of the latter would be improved if the period at which the horse was urged to his speed had been that selected

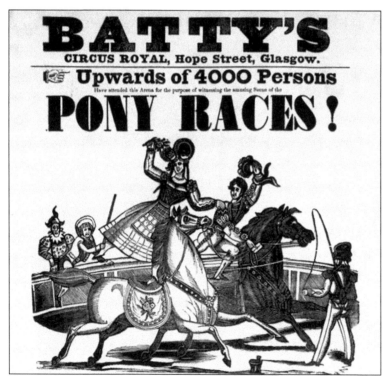

Batty's Circus
Royal, pony races.

for the scene of the storm. Mr Batty gave a specimen of the perfection of his training, on the mare Beda, which seemed to have attained perfect docility. He afterwards, as a Spanish Don, rode and managed six high mettled steeds around the circle, maintaining his slippery footing with all the skill of an accomplished equestrian, besides giving a dramatic colouring to the exhibition.

Unfortunately, fire broke out one night, possibly started by monkeys that appeared in the show and were locked in the pavilion overnight upsetting a small stove, and the pavilion burnt to the ground.

As soon the fire was discovered, the most strenuous and meritorious exertions were made by all on the spot to save the valuable stud of horses; and we are happy to say they were nearly all got out, along with the lion, Wallace, which had been performing for the last two or three nights. This, as may be imagined, was a work of much difficulty and danger, some of the horses having literally to be forced or carried out. Sadly, two of the ponies were destroyed, as was the splendid wardrobe, horse furniture, indeed, everything belonging to Mr Batty and his company.

Batty's shows often included a live fox hunt: 'Mr John Powell as a British fox-hunter on two horses performs some daring feats in the pursuit of a living fox which is admitted into the circle.' Sadly, the fox, which was not killed in the mock pursuit but caught to

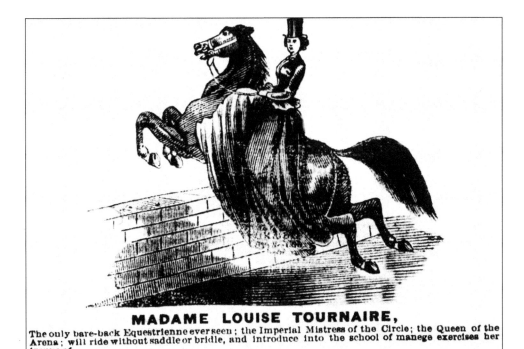

MADAME LOUISE TOURNAIRE,

The only bare-back Equestrienne ever seen ; the Imperial Mistress of the Circle ; the Queen of the Arena ; will ride without saddle or bridle, and introduce into the school of manege exercises her troupe of

Madame Louise Tournaire.

'perform' again, also perished in the fire. Batty recovered from the disaster and continued to tour. In 1848 his Glasgow season took place in a replacement marquee in Maxwell Street but this was not thought quite up to scratch: 'The interior arrangements of the arena might be rendered a little more comfortable for the audience.' There were many celebrated female equestrian performers and that year Batty's circus included 'Madame Louise Tournaire on her highly trained and beautiful steed, Catmanka, who displays the utmost grace and adroit management'.

From the 1830s to the 1850s James Cooke's touring circus presented various seasons in a building on Glasgow Green as part of the Glasgow Fair. One year the show included 'Madame Dumas, the most elegant and accomplished female equestrian and Monsieur Dumas, the brilliant pantomime rider, both from the Paris Cirque Olympique'. For many years the star act was James Cooke's son, Alfred, who was a skilled equestrian. Standing on his horse Alfred entered the ring costumed as Shakespeare's Falstaff and while cantering round the ring recited Falstaff's soliloquy about the follies and limitations of honour. Then, while still standing on the horse's back, he shed his Falstaff costume to reveal an outfit representing Shylock, complete with prop knife and scales with which to extract his pound of flesh from Antonio's bosom. In this new character Cooke declaimed a mixture of lines from several scenes of *The Merchant of Venice*. Finally, Shylock was cast off to reveal the battle attire of Richard III, and Alfred ended his act declaiming, 'A horse. A horse. My kingdom for a horse', before galloping off to wild applause.

Equestrian shows began to evolve into broader circuses with clowns, tightrope walkers, jugglers, acrobats, etc. During one of its Glasgow seasons Cooke's Circus also included 'Mr. Carter, the Lion King, and his wild family of two lions, a tiger, and three leopards'. Carter's elaborate act with his wild cats included a dramatic scenario set in an exotic locale such as Arabia or Algeria.

In 1850 Monsieur Bastien Franconi, the owner of the Cirque National de France in Paris, took over the Maxwell Street marquee and either it had been improved or Franconi's promotion was slightly misleading, as he advertised the venue to be an 'elegant and capacious Equestrian Establishment'. Franconi's troupe included forty-six highly trained horses and ponies, including 'the extraordinary leaping horse, Rob Roy'. While in Glasgow Franconi's son, Henri, married Fanny Gantier, one of the company's equestrian stars. The troupe, along with a large detachment of the 21st Regiment and 13th Dragoons, also took part in a grand spectacle held in the grounds of Glasgow University:

The Gardens were thronged with from ten to twelve thousand spectators, all of them in holiday attire. The entertainments commenced with a representation by the whole strength of Franconi's company of a carousal during the reign of Charles VII of France which was produced with a degree of splendour, including very dexterous tilting performed by the male and female equestrians, in which a surprising degree of dexterity was exhibited. The final part of the evening was the spectacle of the 'Storming of Goojerat', although a little more daylight would have been advantageous in enabling parties to see the operations with greater distinctness. To represent the fortress of the Sikhs, a large space was enclosed and palisaded ... A party of pensioners, dressed as Sikh artillerymen, along with a numerous detachment of soldiers clad in the picturesque

costume defended the fort. The bugle sounds to arms ... The troops in an instant form a square, and a withering volley, followed by a brilliant charge of the British dragoons, completed the rout of the Sikh cavalry. The spectacle was of the most brilliant kind - the booming of the artillery, the rattle of the musketry and the glare of rockets.

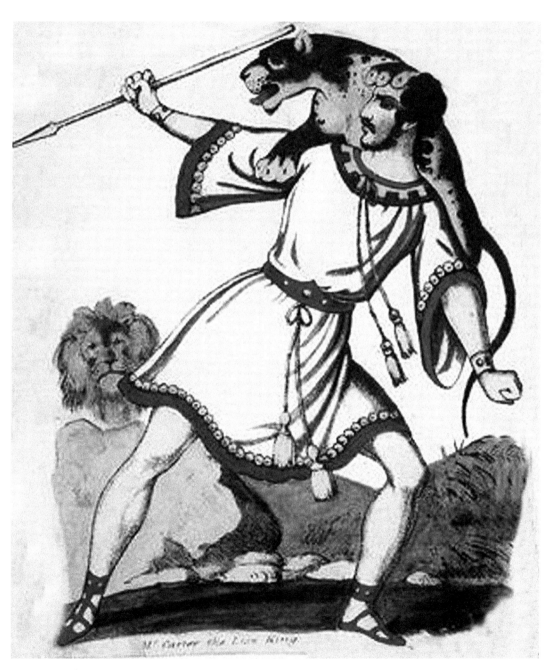

Carter, the Lion King.

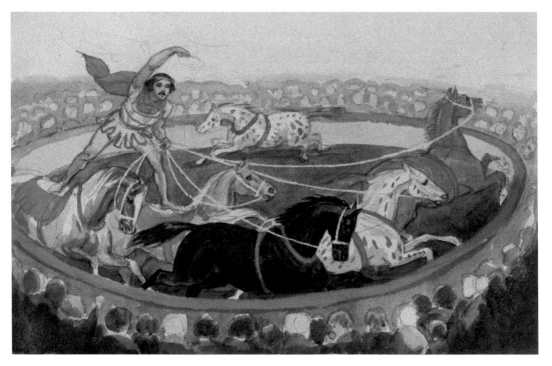

Henri Adolphe Franconi by Jemima Blackburn, 1844.

Franconi's equestrian season in Glasgow ended with a guest performance by 'The Peerless Equestrian' Mr J Powell: 'He will enter the circle as Sandy, the Mountain Shepherd, then changing to the Highland Chieftain, Rob Roy! Mr Powell will introduce the celebrated Newfoundland dog, Wallace, being his first appearance here.'

From 1860 Charles Hengler's Grand Cirque Varieté presented three-week seasons in a large temporary structure on Glasgow Green during the Glasgow Fair. Its 'Magnificent Equestrian Manoeuvres' included 'A new equestrian pantomime entitled *Bold Robin Hood and the Merry Men of Sherwood Forest*'. Hengler himself appeared in the guise of the famous Italian General Garibaldi. In 1867 Hengler leased the Prince's Theatre on West Nile Street and over the next twenty years mounted six-month seasons over the winter. In 1885 Charles's son, Albert, commissioned Frank Matcham, the leading theatre architect of the day, to design a new theatre for the family's circus in Wellington Street:

Apart from the first-class equestrian entertainment Mr Hengler this year introduces a feature which is very creditable to his enterprising spirit. This is the introduction into the arena, under the care of their trainer, Professor Darling, of six fine-looking lions. The safety of the audience is ensured by the temporary erection round the arena of high iron railings, the ring forming one cage. A couple of large boarhounds also come in with the animals, and one of the dogs keeps running round barking at the noble beasts, who retaliate by looking round and giving a playful snarl. At the crack of their master's whip the lions rush about into position like many gigantic performing cats. They form

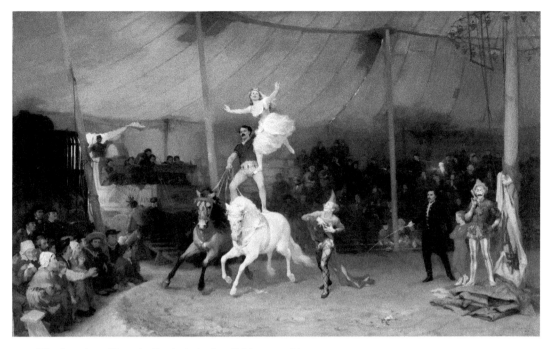

The American Circus by Frederic Arthur Bridgman, 1869.

into two graceful arches, which Nero, one of the boarhounds mentioned, leaps over and runs under alternately. One huge lion forgets to come down, and the trainer, getting the animal over his shoulder, staggers across and drops it among its companions ... One of the lions also rides a bicycle, and Professor Darling concludes his marvellous entertainment by driving three of the animals round the arena harnessed to a chariot.

Eugene Cooke, the son of Alfred of the Shakespearian costume changes, opened a new Cooke's Royal Circus in South Ingram Street. In January 1887, as well as the evening performance that included the usual equestrian acts and clowns, it advertised '100 Zulus and British Soldiers will drill at 12 o'clock, for the grandest spectacle on earth'.

In December 1891 Buffalo Bill's Wild West Show arrived in Glasgow for a three-month season and with over 170 horses and a herd of buffaloes it lived up to its billing as 'the most sensational entertainment in Glasgow'. The show was housed in a huge temporary building measuring 270 feet by 225 feet that had been erected earlier that year as part of the major East End Industrial Exhibition in Dennistoun and had seating for 7,000 spectators. The company included numerous cowboys and seventy native Americans, including Chief Sitting Bull and others who had participated in the Battle of the Little Bighorn at which General Custer's Brigade had been massacred:

The various performers careered into the arena one after the other, and filled the large space, being as savagely picturesque an assemblage as sight-seers looked upon in Glasgow. ... The climax was when white man and Indians, horse and buffalo, rushed

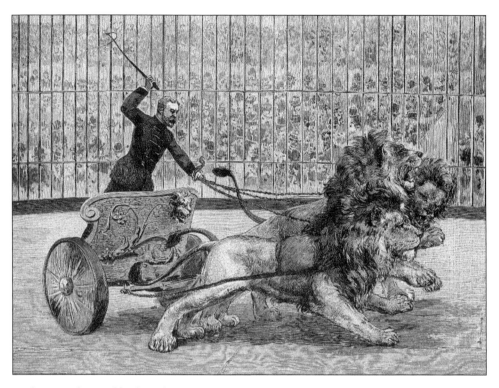

Professor Darling and his lion chariot.

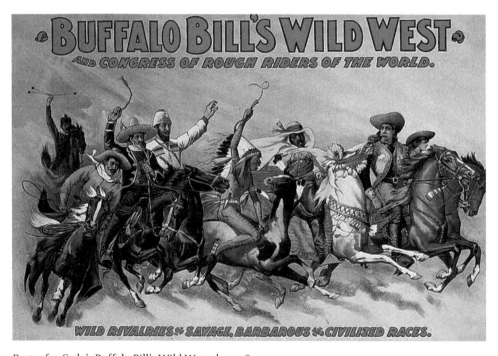

Poster for Cody's Buffalo Bill's Wild West show, 1890s.

in a wild stampede across the arena. The fall of General Custer formed one of the most striking series of pictures shown during the evening. ... It is scarcely necessary to say that all the performers are expert riders.

When Buffalo Bill's Wild West & Congress of Rough Riders of the World returned to Britain in 1904 it played a total of twenty-nine consecutive Scottish venues, including a week in Glasgow. Around 500 horses were used, making this by far the largest equestrian event ever seen in the city:

Members of various tribes of North American Redskins, were the first to make their appearance. These were followed by Arabs, Japanese, Cossacks, American Artillerymen, Cowboys, lady-riders, English Lancers, and others, all of which were superbly mounted and handled their charges with great skill. Some wonderful exhibitions of fine horsemanship are presented by the rough-riders. The Bedouin Arabs show a wild barbaric dash in their style; the Caucasian Cossacks execute such surprising feats as never have been seen in any exhibition heretofore; the American cowboys fully sustain their world-wide reputation for skill and reckless daring; the British and United (sic) cavalrymen display the acme of military equestrianism; but away and beyond them all in ability to do amazing riding on bare-back steeds are the Sioux and other Indian tribes.

In that same year Arthur Hubner took over Hengler's business and opened the Hippodrome on Sauchiehall Street. He included acts such as Martha Cashmore who drove

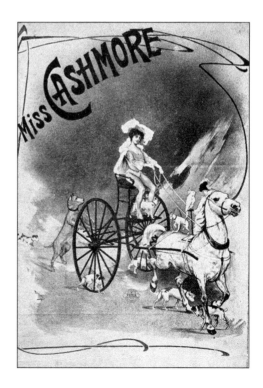

Miss Cashmore and her performing horse and dogs.

a horse-drawn buggy, and trained dogs ran in and out of the wheel spokes and between the horse's legs. The venue later was converted to enable extraordinary water effects to be exhibited. The circus ring, 42 feet in diameter, could be converted within one minute to a tank of 100,000 gallons of water, and the circular platform on which performances took place could be raised and lowered into the bottom of the tank by a powerful hydraulic ram and pumps. Horses and other animals were included in extravagant theatrical shows, such as one described in the *Glasgow Herald* in 1912: *The Balkans* – in which horsemen, wild sheep and bullocks were driven up mountain passes, how a bold youth dived from a dizzy height to rescue his girl, and of the bursting of the floodgates up in the mountains and the stampede of oxen, horses, men and women, the wild plunge and the exciting swim for life.

Many of Glasgow's theatres that had once staged equestrian shows were converted into cinemas, and the horses that audiences watched there, more often than not, were ridden by cowboys and outlaws. The appeal of the Wild West influenced local sideshows during the Glasgow Fair such as Broncho Tom's Wild West Show that was an attraction at the Vinegarhill Fairground in 1915. Although equestrian shows ceased to be staged, horses continued to be an essential part of the circus; the 1933 Kelvin Hall Carnival Circus included around fifty performing horses and ponies, and a troop of zebras.

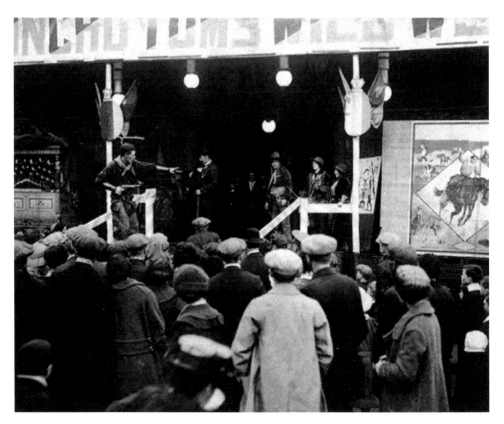

Bronco Tom's Wild West Show at Vinegarhill Fairground, 1920.

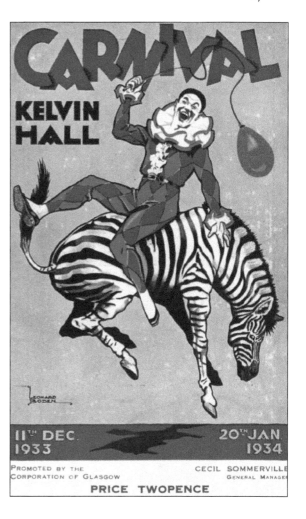

Right: Kelvin Hall Carnival Circus poster, 1933.

Below: Kelvin Hall Carnival Circus finale, 1933.

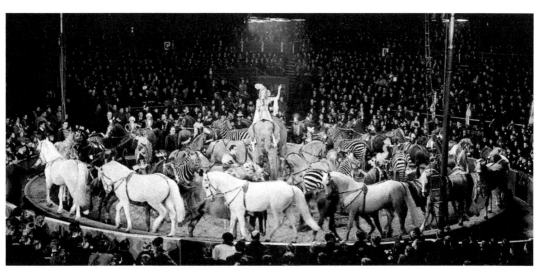

3. Blood Sports

Fox-hunting began in Scotland around the mid-1700s and in 1771 John Orr, later commander of the Royal Glasgow Volunteer Light Horse, and around twenty other Glaswegian landed gentry established the Roberton Hunt, which later evolved into the Lanarkshire & Renfrewshire Hounds. It was not all arduous days in the saddle chasing foxes as indicated by an early minute of the club. It instructed the treasurer to order 'a hogshead of London porter, six dozen strong beer, five dozen port wine, one dozen sherry, and eight gallons French Brandy'. By 1852 the hunt's pack of hounds consisted of fourteen dogs, including 'Bruiser', 'Barmaid' and 'Warrior' who were housed in kennels near Johnstone. By 1920 the pack had increased to over twenty-five dogs.

An example of a day's hunting comes from 1861. It began in Bishopton and the forty or so riders then chased various foxes up to Port Glasgow and back via Paisley to Glasgow. 'Lots of horses having come to grief; two gone at Port Glasgow, one at Paisley and one at Govan.' The report of a hunt in 1906 stated 'A good fox led his pursuers over the hill near Neilston Pad and then along the railway. The hounds simply raced after him and killed the fox in the open near Welkin Farm at the end of a fine forty-five minutes.' Hunts also pursued hares: 'After hunting and killing a fox on Hamilton Moor, the pack had a good run after a hare.' James Murray, a member of the Lanarkshire and Renfrewshire Hounds, saw pleasure in pursuit of an animal:

> What can surpass the healthful enjoyment of field sports? Who is there acquainted with
> their many attractions, and who can relish the excitement of those varied scenes of manly

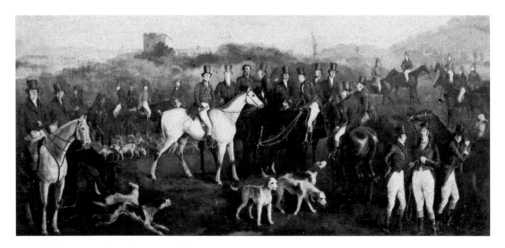

Lanarkshire & Renfrewshire Hounds.

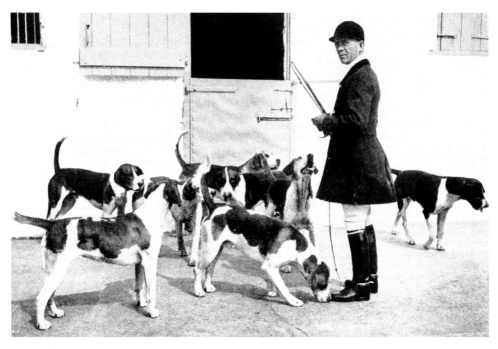

Will Jacklin, Keeper of the Lanarkshire & Renfrewshire Hounds.

diversion, who does not feel his heart bound within him at their bare mention? A taste for the pursuit of wild animals is inherent in human nature. Otter-hunting, above all sports, is one to which the above remarks particularly apply, as every one, without cost, from the peer to the peasant can participate in the fun, if they have only a good pair of legs, a stout heart, and strong lungs, so as to be able to stick to the hounds, and see them working.

Hare coursing was a popular activity and often included wagers on which the dog would catch the hare. In 1840 the *Glasgow Herald* claimed that hare coursing 'evoked that bounding spirit of delight with which one who has been long immersed in the smoke, din, and harassing routine of city existence, flies for even a single day to the enjoyments of the green earth'.

The Lanarkshire & Renfrewshire Hounds is one of a number of Scottish hunts that continues today in spite of the Scottish government passing the *Protection of Wild Mammals (Scotland) Act* in 2002 to ban fox and hare hunting with dogs. The law allows packs of hounds to flush foxes that are then killed with guns, although some believe that some hunts still allow the hounds to kill the animals they pursue.

With no risk of being hunted by hounds, many of the foxes that have taken to living in Glasgow's urban areas are fearless. In the 1990s at least two foxes, or perhaps the same one, were brave enough to interrupt Glasgow football matches and thus gained a brief moment of footballing glory. One of the occasions was a match between Celtic and Aberdeen. The fox appeared on the pitch on Celtic's right wing but in spite of displaying a prowess in evading tackles was not signed up for either club. The singer Michael Marra

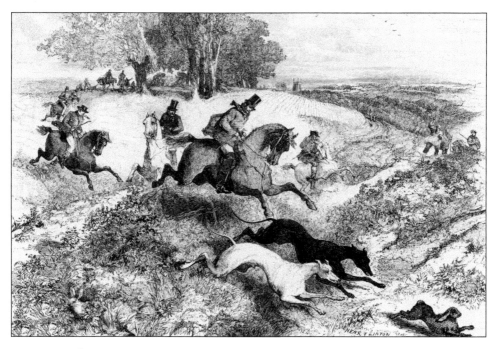

Hare coursing by Henry Linton, 1865.

was listening to the match on the radio and heard the commentator say, 'An amazing thing has just happened, a beautiful and healthy fox has just run on the park.' This prompted him to write a song about the fox's appearance, called Reynard in Paradise.

Another popular blood sport was detailed in *The Statistical Account of Glasgow* published in the 1830s:

> In former times cock-fighting was so prevalent in Glasgow that on certain holidays, school-boys provided cocks, and the fight was superintended by the master. But as civilization advanced, this practice gradually disappeared, and at length the amusement in the estimation of many came under the denomination of cruelty to animals. During the latter part of the last and the beginning of the present century, cock-fighting in this city was conducted in a clandestine manner. In 1807, our cock-fighting amateurs, finding a vacant temporary building in Queen Street, made preparations for a fight, but when the sport had just commenced, a portion of the city and county magistrates made their appearance and dismissed the meeting. Of late, however, the desire for this amusement has so much increased, that a spacious building has been erected for a cock-pit in Hope Street. This building, which is seated for about 280 persons, has suitable accommodation for the judges, handlers, and feeders.

Although the Cruelty to Animals Act 1835 made cock-fighting illegal, almost sixty years later seven Scottish High Court judges ruled that cock-fighting was legal in Scotland. Their extraordinary judgement, arising from an appeal by two Paisley men accused of having

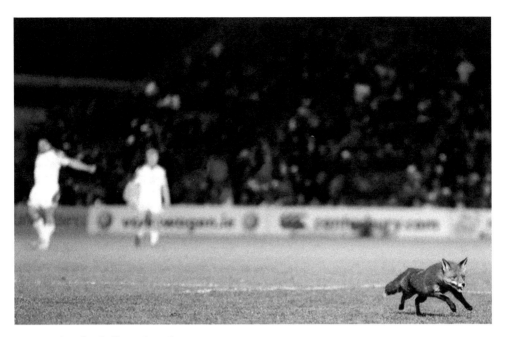

Fox invading football match in the 1990s.

arranged a cock-fight, was based on a view that the game-cock was not 'to be reckoned as an animal in the meaning of the Prevention of Cruelty to Animals Act' and that 'the legality of cock-fighting proceeds on the ground that it is a practice thoroughly well-known and once held in high and honourable repute'. Those who opposed the barbarous practice were outraged and public opinion led to a Scottish ban three years later. Yet illegal cock-fighting continued. In 1917 police raided a stable at North Speirs' Wharf where an illegal cock-fight was in progress and around thirty men scarpered, leaving behind six cocks in cage boxes, their natural spurs cut off in readiness to have steel spurs attached.

One dog racing activity in which no blood was spilt was whippet racing. From the early 1900s through to the end of the 1920s whippet races were held at a track in the Rockvilla area of the city. Whippeting, as it was called, took place over straight grass tracks, usually 200 yards in length. One man would hold the dogs while the owners stood at the race end. At the signal to start, the dogs would be released and race towards their owners, who were at the finishing line waving towels to attract their dog. Whippeting was largely a working-class activity, and a large number of those who owned and raced whippets were miners. Betting was part of the attraction, although at the time such betting was illegal. One Glasgow raid on an illegal betting establishment was 'met with a lively reception from a number of whippets that seemed to resent their intrusion'.

In July 1926 the *Illustrated Sporting and Dramatic News* announced the arrival of a new sport that appeared to threaten whippeting:

A sport new to this country has just been initiated in the north, namely, Greyhound racing. It is analogous to whippet sprinting, although it differs from the latter in several

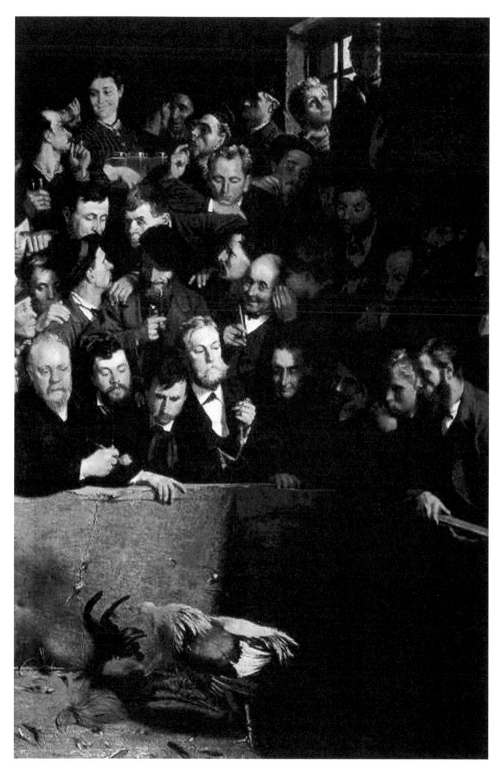

Cockfight by Emile Claus, 1882.

essentials, including distances run. A racecourse, some pictures of which appear on another page of this issue, has been planned in Manchester and has been most carefully constructed. At the starting point, eight wooden stalls, in an exact line, but separate from one another, have been built. A single wire gate covers the outlet of all, and this is mechanically raised or dropped, at will, each competing greyhound being placed in a separate compartment. A dummy hare is provided, which runs on an electric line and is controlled by switches manipulated by human agency. The speed of the hare can be so regulated that the greyhounds are able to come within a certain distance of it but are never able to catch it up.

Mr David Rainey, secretary of the association which controlled sixteen whippet racing grounds in Scotland, when asked if he saw greyhound racing eclipsing whippeting commented:

Greyhound racing will very likely take away the occasional visitor to whippet-meetings, including the man whose desire for a gamble overcomes his dislike of the noise of barking dogs that is an inevitable accompaniment to whippet meetings. The greyhound track, where comparative silence prevails, will be more to his liking. Spectators at whippet grounds are composed very largely of dog-owners and their friends and

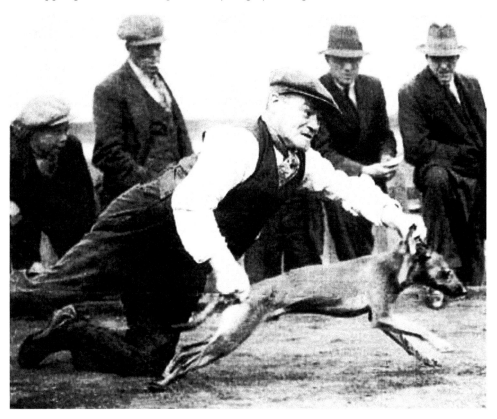

Photo of a miner and whippet by Arthur watts. (The Bystander, 1920)

relatives. Practically every spectator has an intimate interest in one of the dogs. I have a feeling that, while greyhound racing will have a certain amount of success, it will not catch on here as in England. The sporting temperament of the two peoples are not the same, and, in my opinion, in the south the greyhound has a greater appeal.

Unfortunately Mr Rainey was quite wrong. As only betting at horse racecourses was legal at the time, and Glasgow lacked one, greyhound tracks offered legal betting and Glaswegians keen on a flutter flocked to the new stadiums. By 1932 over two million Scots were attending greyhound race meetings, and whippeting, while continuing to take place in other parts of Scotland, appears to have almost disappeared in Glasgow by then. The first greyhound stadium to be opened in Glasgow was Wester Carntyne in 1927, followed the next year by three more: Albion, White City and Shawfield Park, the latter in Rutherglen but much frequented by Glaswegians. The Scottish Greyhound Derby was first run at Carntyne in 1928 and was won by Glinger Bank, a dog trained in Edinburgh. During the Second World War greyhound racing was curtailed but the Scottish Derby was allowed to continue and in 1942 was won by a Glasgow-trained dog. Intriguingly, the prize was a Silver Filigree Casket made in Goa in the seventeenth century that was inscribed 'Scottish Greyhound Derby 1942 – Won by Carntyne's "Ballycurreen Soldier"'.

The introduction of off-line betting in 1960 and competition from other leisure pursuits led to a waning in popularity, and all three Glasgow stadiums eventually closed. Shawfield remains Scotland's only greyhound stadium, although the future of greyhound racing is under threat as there is an increasing call for greyhound racing to be banned. This stems from concerns at the number of racing dogs put down at the end of their track careers, injuries sustained in training and racing, and dogs dying unusually young. Recent examples of dogs testing positive for banned drugs such as cocaine and amphetamine have further added to the calls for its end in Scotland.

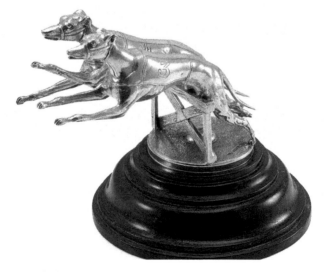

Greyhound racing trophy by George & John Morgan, Glasgow, 1927.

4. Menageries

As European trade expanded across the globe, ships brought back to Britain an increasingly diverse variety of animals, and royalty and aristocrats created menageries and aviaries to house their exotic creatures. From the seventeenth century onwards showmen in London began to purchase 'strange beasts' and charge the public to view them. In spite of the poor roads and difficulty in transporting non-domestic animals, some of the owners of London menageries began to tour their animals around Britain. However, given Scotland's distance from London few were seen in Glasgow before the 1800s. One of the few exhibited in the city before then was a cassowary brought from London by Gilbert Pidcock in 1780. While it was in the interest of owners to look after their expensive animals, the conditions the animals travelled in were usually inadequate and their needs not always understood, and on its way back to London Pidcock's cassowary died in Durham. Undaunted, Pidcock stuffed the carcass himself and by displaying the preserved bird ensured his investment was not completely lost.

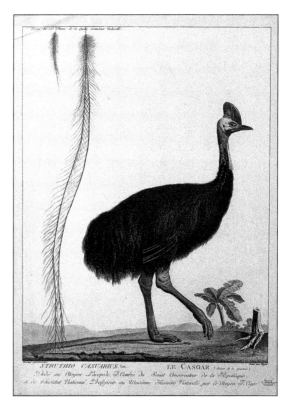

A cassowary walking next to a display of its feathers and a skeletal foot. (Etching by S. Miger, *c.* 1808, Wellcome Collection)

Pidcock's menagerie at Exeter Exchange in London was the largest of its kind and contained a diverse range of animals from around the world. In 1798 Pidcock again headed north, this time with a number of animals that travelled in four wagons, the elephant's pulled by eight horses. His menagerie was exhibited in Gallowgate and in addition to the elephant there was a tiger, an Asian antelope, a vulture and a pelican. Also exhibited was a two-headed heifer that the *Glasgow Mercury* reported to be 'the most curious production of nature ever exhibited in this kingdom'. Robert Reed, who under the pseudonym Senex wrote articles for the *Glasgow Herald*, recalled visiting the two-headed cow: 'The animal was very mild and gentle and when I patted its fully formed head it took this very kindly, and seemed pleased with my attention.'

Exhibitions of menageries in Glasgow became more common during the nineteenth century. In 1811 Signor Stephen Polito's Menagerie included a 2-ton rhinoceros, advertised as 'The Horned Horse – the most desirable production of nature's wonderful works'. Glaswegians were amazed to have their first sight of this massive beast. Other animals Polito brought that probably had never previously been seen in Glasgow included a panther, a porcupine, a hyena, a sloth and a black swan. Also exhibited around this time was a polar bear that Robert Reed recalled viewing:

The white polar bear was stationed alongside a large tin trough or tank, filled with water, in which it had the liberty of taking a bath. It was a very fine specimen of the species, being upwards of twelve feet in length, with hair long, soft, and white. It had more of a placid than of a ferocious look, but appeared extremely uneasy at being confined, and seemed to feel that it was quite out of its natural element, which it showed by occasionally roaring dolefully, as if in distress. In order to silence it, the keeper used to dash a pailful of water in its face, which it took very kindly, and so ceased its clamouring.

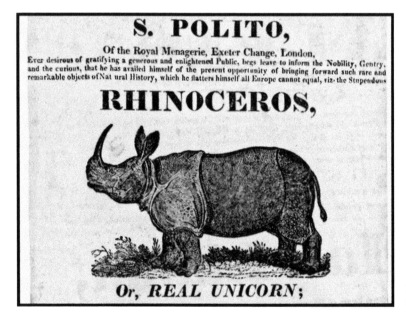

Polito's rhinoceros.

It was not shut up in a cage, but only confined to the floor by an iron chain, which was of a length sufficient to enable it to climb into the water trough or tank at its pleasure.

Travelling menageries were hugely popular and often came as part of the Glasgow Fair in July. George Wombwell's Menagerie was the most regular visitor to the city and over the decades the number and diversity of the animals displayed expanded. In 1822 along with the usual elephants, lions, tigers and suchlike, Wombwell brought llamas, raccoons, an ostrich and a crocodile:

> To enumerate the rare and curious animals, birds and reptiles composing Wombwell's Menagerie is impossible. Let it suffice, that every region of the Globe - the burning sands of Arabia and the frozen snows of Greenland, alike contribute to render it what it is - unequalled for variety, extent and value. This expensive establishment is not equalled in magnitude and interest by the collections of some of the first Potentates in the world.

There was intense competition among the various owners. At the Glasgow Fair in 1845 both Wombwell's and Hylton's menageries were exhibiting and both lowered their admission price to a penny to compete. Displaying new additions was one way of attracting spectators and in 1849 Wombwell arranged for an 'ouranoutang, about three years old, which was only landed in London on Friday last' to be speedily despatched to Glasgow in time for the menagerie's opening day. It was not only exotic animals that were

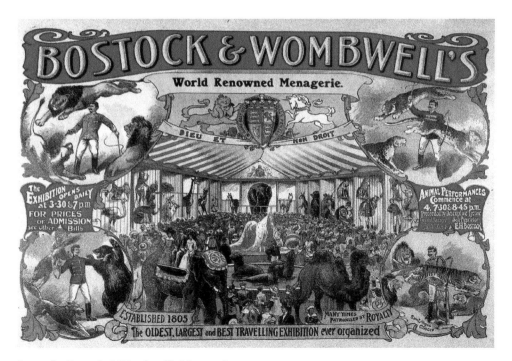

Poster for Bostock & Wombwell's Menagerie.

exhibited. In 1860 Wombwell advertised that the show would include 'That extraordinary race of men, The Zulu Kaffirs, or Wild Men of Africa'. The surgeon and naturalist Francis Buckland described Wombwell's set-up:

The establishment consists of fifteen vans and when they arrive on the exhibiting ground they are formed into two lines, with the long elephant van at one end, and the 'pay here' van at the other, the whole being roofed over with canvas. Between thirty and forty men are employed as keepers, and forty-five horses are attached to the establishment to drag the vans. Many of the keepers have 'apartments' in the vans behind the animals - one man having for his neighbour the hyenas; another the bear who 'rattles his chain all night'; another the lioness and her cubs which cry as loud and as continuously as any babies. All the animals are carried in the vans, except the two elephants; these intelligent beasts walk, but yet in such a manner that they shall not exhibit their huge cameos for nothing. Accordingly a van 27 feet long is provided, the bottom of which comes out, and the elephants march away famously, their huge feet only being exposed to the public; this acts as an advertisement, and makes the folks anxious to see the rest

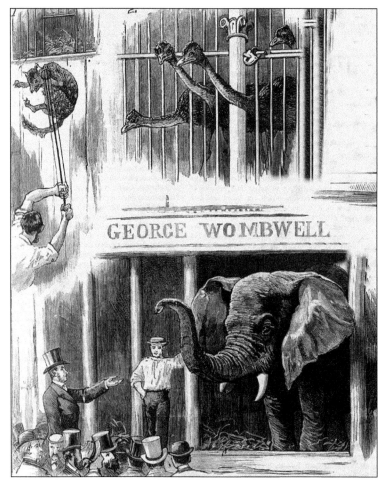

Wombwell's Menagerie. (*Illustrated London News*)

of their bodies. They can march twenty miles a day, but ten miles is about their usual day's journey. These elephants are wonderful performers. When not performing they stand like importunate beggars, thrusting their long trunks among the spectators for halfpence, which they immediately spend at a cake and nut stall within reach of their trunks; they place their money on the stall, and receive the eatables in return. When not served immediately, they ring a bell to call the attention of the black man who keeps the stall, and let him know they wish to make a purchase.

Menagerie owners did everything they could to ensure their expensive animals survived but conditions for the animals were harsh. It was not until 1900 that Parliament introduced an act to prevent cruelty to animals in captivity. Although this prohibited 'unnecessary suffering' it did not spare menagerie and circus animals the stress they suffered from the constant travelling, as Thomas Frost described in his 1874 book *The Old Showmen and the Old London Fairs*:

It is impossible to do justice to animals which are cooped within the narrow limits of a travelling show, or in any place which does not admit of thorough ventilation. Apart from the impracticability of allowing sufficient space and a due supply of air, a considerable amount of discomfort to the animals is inseparable from continuous jolting about the country in caravans, and from the braying of brass bands and the glare of gas at evening exhibitions.

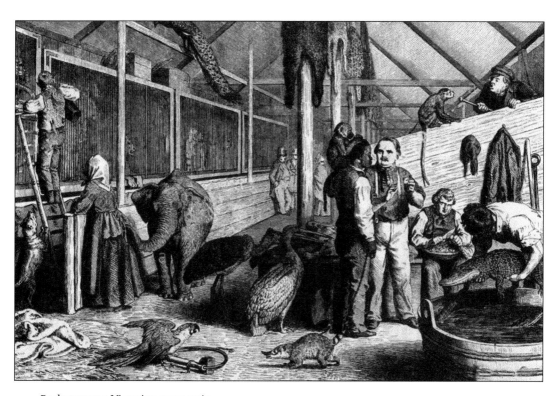

Backstage at a Victorian menagerie.

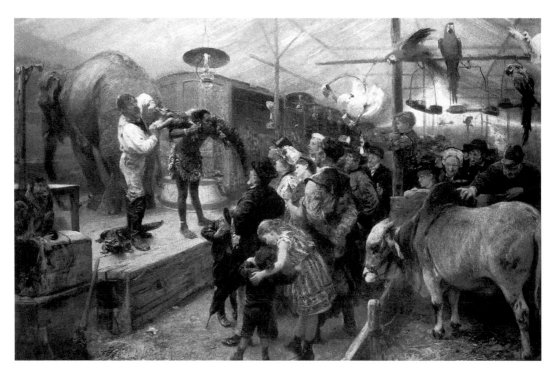

Menagerie by Paul Friedrich Meyerheim, 1894.

In 1866, following George Wombwell's death, his menagerie passed to Alexander Fairgrieve, an Edinburgh man whose wife was a niece of the Wombwells. He managed its touring for six years but then decided to end the business and auctioned off all the animals in Edinburgh's Waverley Market. Thomas Frost described the sale:

> A sale of wild beasts is an event so novel and out of the way that it excited considerable attention, not only in Edinburgh, but all over the country. Buyers were numerous, and included well-known naturalists, circus proprietors, and representatives of zoos in Britain, America and France. Perhaps the most prominent was Mr Jamrach, the most extensive dealer in wild animals in the world. ... The auctioneer commenced the sale with the monkeys, which were recommended as pets for the drawing-room, as lively, frisky and intelligent ... The oldest inhabitant in the establishment was the condor, who had been attached to Wombwell's Menagerie for forty years, and despite his age he fetched £15. ... Mr Jamrach secured the magnificent performing tigress 'Tippoo' for £155. ... The black-maned lion 'Hannibal,' six and a half years old, said to be the finest and largest in Britain, was started at £50, and the bidding was comparatively slow for a time. On reaching £225, the auctioneer said he was ashamed of such a ridiculously small price being offered for the finest lion in the world, and he was sure that 'Hannibal' was as disgusted as he was, and would turn his back on the crowd. Sure enough, the animal did at that moment deliberately turn round, and the amusing episode created some liveliness in the bidding. 'Hannibal' was eventually knocked

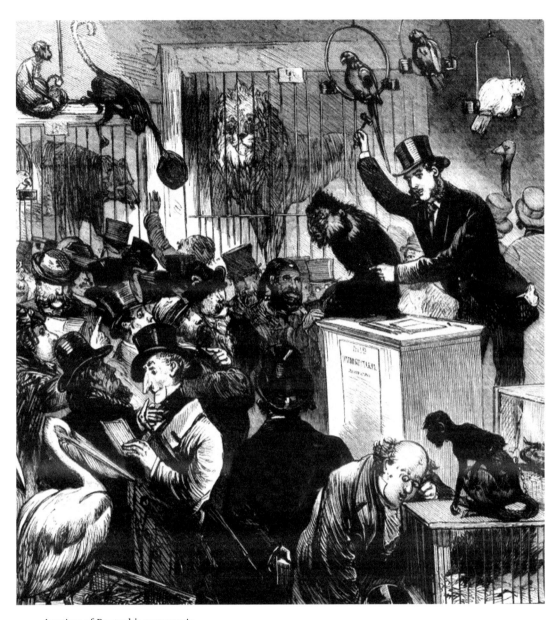

Auction of Bostock's menagerie.

down for £270, to be sent to the Zoological Gardens in Bristol. ... Competition for the large performing elephant, Maharajah, was limited, and this was the only animal which was sold much below its value. For a time the bidding rested at £380, till a suggestion was made that a prominent butcher should invest and introduce a new elephant sausage. The vision of mammoth sausages quickened the offers, and at last, by dint of perseverance, the figure reached was £680, at which price Mr Jennison secured it for his Manchester zoo.

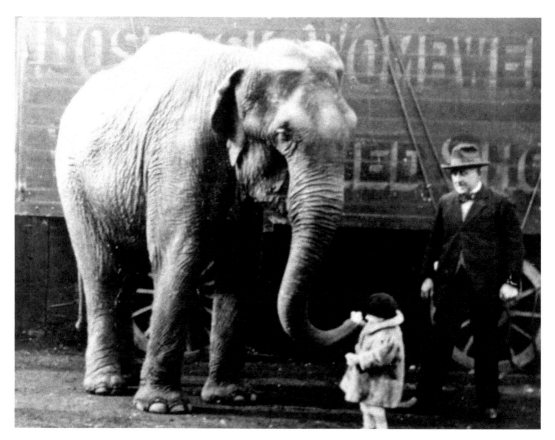

Edward Bostock.

Wombwell's business was bought by Edward Bostock, whose menagerie had often been exhibited in Glasgow, and the renamed Bostock & Wombwell's Menagerie continued to visit the city. Bostock later moved to live in Glasgow and opened a permanent menagerie zoo there. In 1871 the council decided that all travelling shows, including menageries, should no longer be exhibited on Glasgow Green, and so when Manders' Menagerie came in 1872 it had to set up in Dalhousie Street near Bath Street, much to the irritation of nearby residents:

> Why have the authorities prevented the shows in Jail Square? There was ample room for them: they were away from dwelling houses, and those who did not like them could keep out of their way. Now we have Manders' Menagerie next door to us. The establishment is a respectable but a noisy one, and myself and the neighbours are much disturbed by the roaring of the animals, Great crowds gather about, too, in the evening, and the pavement, and sometimes the street, is blocked up. We all suffer much annoyance. I do not think the City Councillors would be content to permit such a noisy nuisance within ten yards of their residences.

In 1908 a small menagerie was opened by Albert Pickard in the Panopticon Theatre on Trongate. Pickard was an eccentric showman and at the Panopticon showed early 'bioscope' films, variety and freak shows, and established a waxworks, sideshows and menagerie in the building. The menagerie was called 'Noah's Ark and Glasgow Zoo' and Pickard created a travelling horse-drawn wagon to advertise it. On top was a small model giraffe and on the sides various quirky slogans, including 'It only eats children' and 'The Beast is Armless'. The zoo advertised bears, baboons, porcupines, wallabies, monkeys and a variety of birds, and stated in capital letters 'No stuffed animals or white mice'. However, it only lasted a few years.

Although specialised touring menageries disappeared in the early decades of the twentieth century, the circuses that toured to the city often included small menageries displaying animals that were used in the circus acts. From 1921 through to the 1980s the annual Kelvin Hall Carnival and Circus included a menagerie that latterly became advertised as a children's zoo:

Glasgow without its Carnival and Circus for the Christmas and New Year season would be very incomplete indeed. Amid a flood of electric light young and old alike can revel to their heart's content in 'all the fun of the fair'. On every hand there is an endless

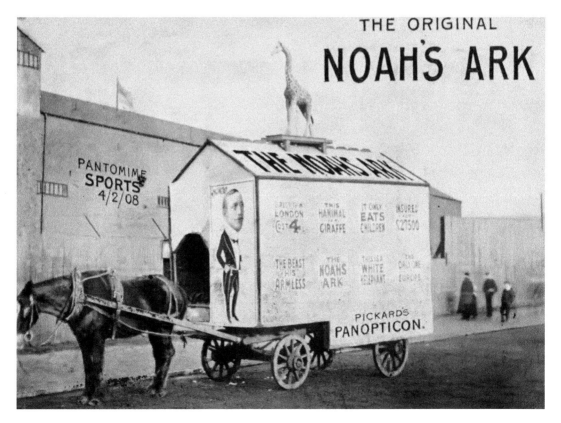

Pickard's 'Noah's Ark' advertising cart.

array of amusements from the old time merry-go-round, cake-walk, and switchback to more modern electrical novelties in the shape of tricky little motor runabout tracks and a figure-of-eight railway. There is a remarkably fine collection of animals, birds and reptiles in the menagerie but of even greater interest is the spectacular entertainment provided in the well-equipped circus. There is much fine old-fashioned clowning: the acrobats and equilibrists call for the heartiest admiration; the equestrian feats are many and clever; there are displays of equine, canine and elephantine sagacity to create wonder.

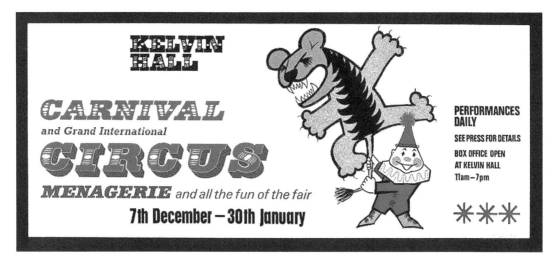

Poster for Kelvin Hall Carnival, Circus and Menagerie, 1965.

5. Performing Animals

One of the earliest performing animals to be seen in Glasgow was a 'learned horse' brought by William Banks in 1596. Banks had trained the horse, named Marocco, to do a number of tricks including walking on two legs, distinguishing between colours, counting coins and indicating numbers on a thrown dice. At the end of the act Marocco would bare his teeth, whinny threateningly and chase Banks offstage to much applause. Banks' act

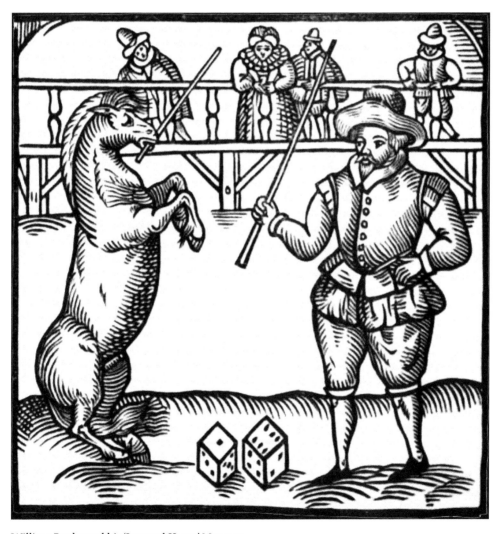

William Banks and his 'Learned Horse' Marocco.

brought him wealth and fame. Many others copied the act and 'learned horses' regularly appeared in Glasgow. In 1764 Mr Zucker exhibited his 'learned little horse' in the White Hart Hotel in the Gallowgate to great acclaim:

> The little horse's wonderful knowledge is not to be paralleled by any animal in this kingdom, or perhaps in the whole world. He wants only speech. As a specimen of his abilities, we shall mention the following particulars, viz. He makes a polite and curious compliment to the company; tells the value of anything which is shown to him; he plays at cards, and finds the place where the card is hid; shows by a watch the hour of the day, and understands arithmetic; he distinguishes ladies from gentlemen; he plays at dice, and is always sure to win; he drinks the company's health like a human person; his master borrows a piece of money of one of the company, and throws it on the floor; the horse takes it up, and returns it to the person that lent it; when he is told that he is to leave the empire or go to the Grand Turk he shams lame, and walks about the room as cripple; but when he is told he shall be excused, he immediately recovers, makes his compliments on his knees, and thanks the company.

The wider import of foreign animals led to many being exhibited and probably the first non-native performing animal was brought to Glasgow by a Mr Wilkins in 1681 as recorded by Robert Law, a Glasgow minister:

> An elephant was sent through the island for sight to gain money; never was there any elephant seen in Scotland before, and it was brought to Glasgow in January 1681, and was seen by many; it was then eleven years old; a great beast with a great body ... It was taught to floorish the collours with the trunk of it, and to shoot a gun, and to bow the knees of it, and to make reverence with its big heid. They also rode upon it.

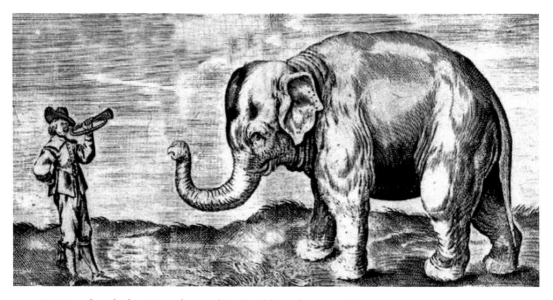

Painting of an elephant toured around Scotland, by unknown artist, *c.* 1700.

Wilkins then travelled with his elephant to Ireland and while in Dublin a fire broke out in the booth in which the elephant was being kept and it died.

Even one of the most reviled creatures of the day had its time in the limelight. In 1768 Sobieski Boverick, a renowned London watchmaker, took lodgings at the Mason's Arms in the Trongate and there exhibited his 'Miniature Curiosities', charging a shilling for entry. His extraordinary minuscule exhibits included 'a pair of steel scissors weighing but the sixteenth part of a grain, which will cut a large horse-hair', and 'an ivory mini-carriage with figures of six horses attached to it – a coachman on the box, a dog between his legs, four persons inside, two footmen behind, and a postilion on the fore horse, all of which were drawn by a single (human) flea'. This was an early example of a 'Flea Circus', later a regular entertainment in the nineteenth century. However, as Robert Reed recounted in the *Glasgow Herald*, Boverick's flea had a tragic accident while in the city:

> A country wife, from Pollockshaws, having come to Glasgow on a market day to sell her fowls and eggs, resolved to see the show; accordingly, without knowing exactly what she was about to see, she paid her admission money, and directly marched up to the table

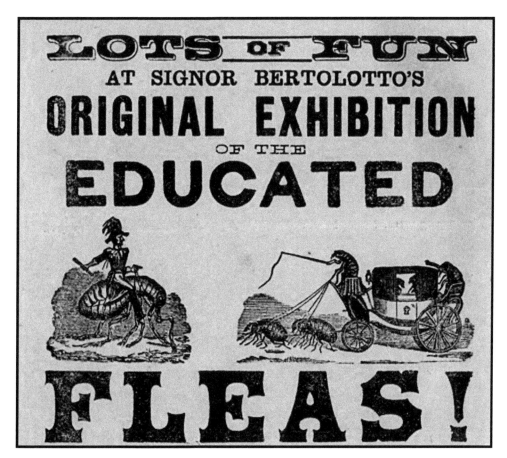

Poster for a flea circus.

on which the flea was performing its task of drawing the ivory coach and coachman. The poor woman looked only to the flea, and instantly turning down her thumb nail upon it, cracked it in a moment, exclaiming — 'Filthy beast, wha could hae brought you here?' The showman, in a violent rage, seized the woman by the throat, and demanded how she dared to kill the flea. The astonished woman, not knowing that she had done anything wrong, exclaimed — 'Losh me, man, makin' sic a wark about a flea; gif you come wi' me to the Shaws, we'll gi'e ye a peck o' them, and be muckle obliged to you for takin' them.' As the woman was a widow, and possessed little or no property, Mr. Boverick thought it most prudent to put up with his loss, in place of going into a court of law for damages. In the present times, the value of a flea would be a curious question at a jury trial.

Another unlikely performing animal was 'The Learned Pig' that in the 1780s was exhibited in London by Samuel Bisset, a Scottish showman, to huge acclaim. When Bisset died a Mr Nicholson toured the pig, or more likely a replacement animal, around Britain. In 1787 it was exhibited in King Street. The *Glasgow Mercury* was impressed:

Among the infinite number of curiosities hitherto offered to the inspection and attraction of the public, there are none which lay so great a claim to our attention and approbation as the wonderful and astonishing performances of the 'learned pig' now exhibiting in Mr Frazer's dancing hall in King Street. The entertaining and sagacious animal casts accounts by means of typographical cards, in the same manner as a printer composes, and by the same method sets down any capital or surname, reckons the number of people present, tells by evoking on a gentleman's watch in company what is the hour and minutes; he likewise tells any lady's thoughts in company, and distinguishes all sorts of colours.

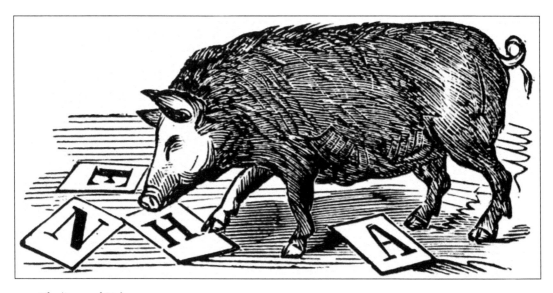

The 'Learned Pig'.

In 1821 The Circus theatre in Dunlop Street staged *The Shipwreck of the Grosvenor East Indiaman*, 'a new grand historical Bruno-canine quadrupedal melodrama in which Mr Simpson with his wonderful performing dogs and sagacious bear will appear'. While the advertisement stated that 'the real bear will exhibit the docility of a child in the representation of a great variety of striking incidents and affecting situations', no mention was made of the role of the dogs although at this time there was a fashion for canines to star in 'dog dramas'. A popular one, *The Dog of Montarges,* was performed in the Theatre Royal in 1858. In this melodrama, based on the factual assassination of a French army officer, the dog saves his master from execution by exposing the real assassin. Part of the attraction for audiences seeing animals on stage was not simply the novelty, but a hope that the animal actor might succumb to a natural inclination and so undermine the dramatic moment.

Throughout the nineteenth century many performing elephants visited the city. The one that came in 1838 as part of Batty's Royal Circus was called Jack and he was partial to a tipple. On his arrival in Glasgow, having walked from Edinburgh, Jack was being led down Saltmarket when he came to a halt at the spirit shop of Mr McLaren. Jack refused to move until he had been supplied with half a gallon of strong ale. At the Market Inn,

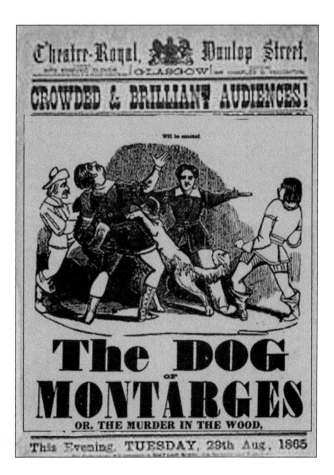

Theatre Royal poster for *The Dog of Montarges.*

200 yards further on, the elephant took another 'slight refreshment', and before leaving the Broomiclaw to head for Glasgow Green where the circus was set up, Jack visited a third inn where 'he had two half munchkins (a pint) of the best Islay whisky. Jack then followed his keeper through the streets with the docility of a Newfoundland dog.'

The most popular of all the exotic animal acts were those involving lions, tigers, and other wild cats. These began to appear in travelling menageries and circuses following the American lion tamer Isaac Van Amberg's visit to London in 1838 as his act caused a sensation. In 1847 Wombwell's Menagerie featured Mrs King, 'the Lady of Lions', who was the first recorded female lion tamer in Britain:

> We have witnessed Van Amberg's exhibition among the lions; but we must confess that Mrs King surprised us more than all. There is a large cage and crouched in a corner are three lions and two lionesses, the Royal Family of the Forest. ... She enters, cracks the

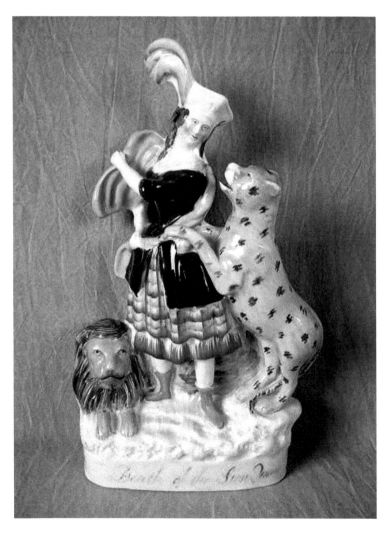

Ella Bright, lion tamer – Staffordshire Pottery, 1850.

whip, and away round the den, scamper the whole troop. … She sits in the corner, and calls one of the royal beasts to her; it comes and lays itself down on her lap, and looks monstrously like an animal enjoying a luxurious siesta. Where are the other savages? Grouped round Mrs King's conquering feet! The Royal pet is heavy, and loath to rise … How is Mrs King to act? … Mrs King flings the Royal lounger off, cracks her whip, uses some cabalistic words—and away again scamper the whole seven. She then places her hand high against the grating, and with a miniature dog-whip compels the Great Mogul himself to bound over her raised arm, like a docile spaniel. Then, with a presumption that few of either sex would venture, Mrs King seizes a pair of Royal jaws, and knocks upper and lower together … She pulls and teases, and strokes down the brutes, and then carelessly walks out, the iron door snapping after her.

Such acts were extremely dangerous. In 1850 Wombwell's seventeen-year-old niece, Ellen Bright, died in Chatham while trying to emulate Mrs King. The inquest into her death took place at the regrettably named Golden Lion Inn and the jury heard how the tiger 'had seized her furiously by the neck', inserting the teeth of the upper jaw in her chin and closing his mouth, inflicting frightful injury in the throat by his fangs.

Monkeys were frequently exhibited, and Franconi's Circus in Maxwell Street introduced a new attraction in 1850, 'The Monkey Steeple Chaser'. This act was first mounted in the family's circus in Paris before being brought to Glasgow and it is mentioned in a poem by Charles Hervey published in *Ainsworth's Magazine*:

What are people laughing at? Hush, don't you see
An ugly young monkey, now two, and now three,
Four – five -and each strapped on the back of a pony,
Belonging to good Monsieur Victor Franconi:
When 'crack' goes the whip, and away they all fly,
And jump over hurdles about a foot high,
Once, twice round and home.

Both monkeys and bears were toured around the streets of British towns and cities by foreign itinerants, and these were often made to perform a 'dance' for paying spectators. In 1875 Antonio Dallori and his performing bear, Bruin, were entertaining passers-by in the High Street when one of Glasgow's Bailies, a pompous man nicknamed Bailie Hunkers due to his obsequious nature, strode out from one of the vennels on his way to a meeting. Bailie Hunkers expected people to make way for him and while the spectators did, Bruin did not, so the irritated Bailie drew his sword and gave the bear a jab. The bear, infuriated by the pain, grabbed the Bailie and swung him round in a sort of dance, growling menacingly. A brave spectator rushed to rescue Hunkers but only managed to send the bear and the Bailie tumbling into a filthy puddle of waste. The only part of Bailie Hunkers wounded was his pride but that was sufficient damage for him to insist that Bruin should be executed. On the following day, Bruin was lined up in front of an army firing squad and 'after receiving a great many shots, expired, grumbling, no doubt, as bears are in the habit of doing, at the hardness of her fate'.

The Monkey Steeplechase.

Venues were always seeking something new to attract audiences. In 1860 Wombwell's Menagerie advertised 'The Musical Elephant that will play fashionable melodies on the organ – an Operatic air, The Jolly Dogs (by particular desire) and God Save the Queen'. In 1893 another elephant that was in the city with a touring circus was taken to Green's Billiard Rooms in Duke Street, and manoeuvred through a narrow entrance and down a flight of twenty steps. Once there the elephant 'holding the cue with its trunk pocketed the red into the middle pocket to the delight of the hundred onlookers at this unique game'.

Performing dog acts regularly featured in circuses and variety theatres. In 1870 the Scotia Music Hall featured 'Mr and Mrs Wallace, character duologue artistes and broadsword combatants, with their highly trained champion performing dogs', while

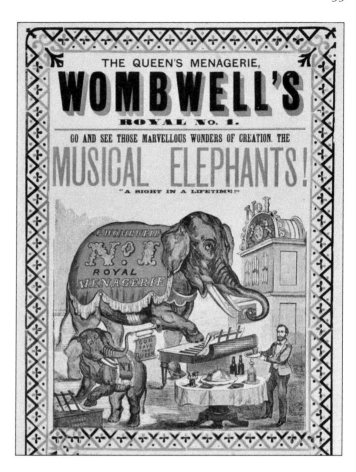

Wombwell's Musical Elephants!

in 1913 it was Lipinski's Forty Dog Comedians that amazed and amused audiences at the Empire Theatre:

> With the stage set to represent a German Town, these wonderfully intelligent creatures become the inhabitants. They drive and ride on motor buses and cars; a fire breaks out and one phones the police; they come as a fire brigade and rescue the inmates. The most remarkable thing about this show is that there is no trainer on stage – they do all their little bits quite on their own.

Performing cats were less common and the reason was explained in an article about Professor Frederick's troupe of performing cats, canaries, mice and rats that appeared at the Scotia Music Hall in 1889:

> The pride of Professor Fredericks' troupe of cats is a black animal named Sloper, who originally cost his master sixpence. A fifty-pound note would not buy him to-day. This treasure is just now suffering from a severe cold, and Professor Fredericks has been obliged to put a mustard plaster on his throat. 'Cats are willing enough to learn, but

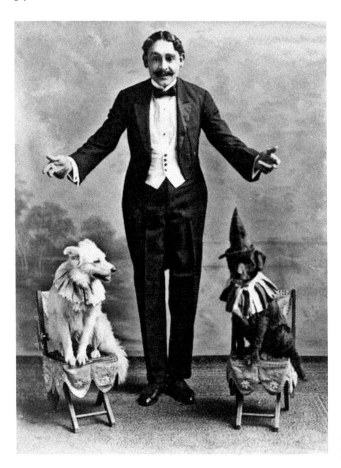

Mr Weston and his performing dogs.

'they are unreliable', says Professor Fredericks. 'Sloper may have walked the tight-rope five nights with elegance and precision, but on the sixth he may refuse. It's obstinacy and when the fit is on them, the only way is to let them rest.' If there is one thing of all others that Sloper most dislikes it is mice, and next it is canary birds. He treats both of them with contempt. One of the striking features of the performance was to see him walk a tight rope literally strewn with these animals. He lifted his feet gingerly over mice and birds, and the little mishap that occurred in the second part of the journey was due entirely to his severe cold. He sneezed one of the canaries off the rope and on to the floor; but he made up for it by returning with a mouse on his back.

In 1894 the Peoples Palace in Watson Street, Gallowgate, announced 'The management have this week procured Professor Henri's Boxing Kangaroo, which will accompanied by the coloured boxer, Black Jack. The boxing kangaroo recently was the rage in London. The coloured boxer will spar three rounds with local boxers each evening prior to his bout with the kangaroo.' One minister blamed such attractions for people no longer attending church: 'How could a man who had been watching the boxing kangaroo on Saturday night enjoy a discourse by a minister on Sunday morning?'

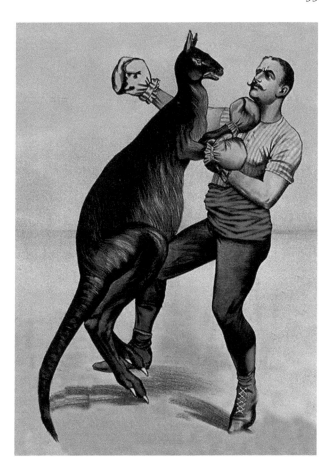

A boxing kangaroo.

The Glasgow Fair held in July dates from 1190 when William the Lion, King of Scotland, gave permission to Bishop Jocelin to hold festivities within the boundaries of Glasgow Cathedral. In the nineteenth century the fair was held on Glasgow Green and attracted showmen from all over Britain. Menageries and performing animals of all kinds were a common attraction and in 1872 the *Glasgow Herald* reported that the fair contained 'the usual run-of-the-mill representation of monstrosities, including giants and fat ladies, and speaking fish and performing dogs, birds, hares and the like are in abundance'. By 1900 the fair had moved to Vinegarhill Street in the Gallowgate and a journalist writing in *The Era* in 1900 paper described the scene:

What a noise! The yelling, howling, swearing, laughing, thieving and devilry. What a combination of brass bands, steam whistles and organs! Here every human contrivance is put into operation in order to draw the hard-earned copper from the pockets from the artisan. Everything under the sun, from 'Birds of Paradise' to 'Tamed Rats', all are crowded together in a small square for the benefit of holiday makers. Trumpet speaking men proclaim the excellence of their particular show, about which 'there is no deception'. Zulus dressed in their native costume execute war dances on the platform, and invite

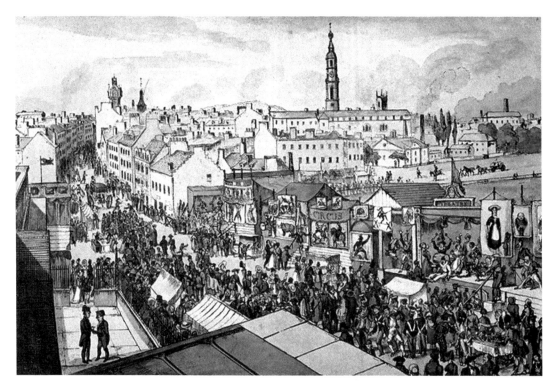

The Glasgow Fair, 1850.

visitors to step inside. Tragedians, arrayed in all their glories of tin helmets and spangled jackets, with wooden swords, loudly assert that they will play 'Hamlet in five long acts'. Fairies, in satin and muslin bid defiance to the time honoured custom of keeping behind the curtain, and strut on the outside stage as alligators, that is if the representations on the canvas are correct, and a sudden impulse to view the aforesaid snakes seizes me. But my desire to enter is nipped in the bud as a sheet of paper the writing on which announces the show is 'full', so I have to pass on.

Glasgow was a popular venue for travelling circuses and almost all included performing animal acts. When Bertram Mills Circus came to the city in 1935 the *Glasgow Herald* review commented on how popular animal acts continued to be

Six baby elephants went through their exercises; sea-lions balanced balls, walked the tight-rope and even played the National Anthem on a series of trumpets; tigers leaped through hoops and rolled over and over on the word of command; and doves when 'shot' flew back down to the marksman.

Even during the Second World War circuses came to the city. In 1943 the programme for Pinders Circus included 'Rodger, the Alsatian Dog; the only one performing in a travelling circus' and 'The Great Ko-Ko with his Performing Horses and Ponies'.

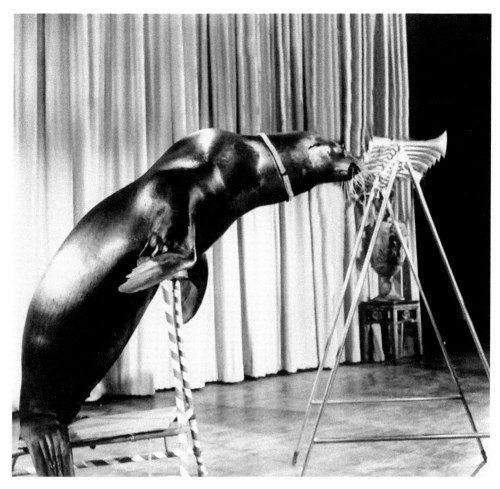

A seal playing musical horns.

Yet many circuses struggled due to competition from films. Performing animals often featured in American movies and in 1943 audiences were packing cinemas to see *Lassie Come Home*, the first of a series of films featuring a collie dog, and *King of the Cowboys*, showcasing the cowboy star Roy Rogers and his equally famous horse Trigger, 'the smartest horse in the movies'. Although Lassie never made it to Glasgow, Roy Rogers and Trigger visited in 1954 for a single appearance at the Empire Theatre. During their two-night stay they were booked into the Central Hotel and the hotel's bridal suite was cleared of furniture and strewn with straw to provide a comfortable stable for Trigger. In 2012 Desmond Lynn recollected the arrival of the famous pair: 'I was one of the bellboys and just fifteen. Roy Rogers came over to talk to me about getting the horse into the elevator. I said, "You're kidding me on, this is a passenger lift, but you might get him into the luggage lift." But that was still too wee. Trigger had to be taken up the stairs. Trigger spent the night there but the following night, the horse stayed at the police stables.'

From the 1820s through to the mid-1980s the Kelvin Hall Carnival and Circus took place over the Christmas festive period and offered a variety of animal acts. One that was especially popular in the 1960s was 'Helmbrecht Hoppe and his Unrideable Mule'. A seemingly docile mule was introduced into the ring and a prize offered to anyone who could ride. Ten or so members of the audience would volunteer, mainly young men out to impress their girlfriends, but each contestant soon discovered that the docile mule was in fact a savage bucking beast and ended up being tossed to the sawdust within seconds. Then a soberly dressed, middle-aged man would climb into the ring, in spite of the loud protestations of his wife who would be trying to drag him back into his seat, and mount the mule. To the audience's amazement, and wild applause, he would victoriously ride the now compliant mule round the ring.

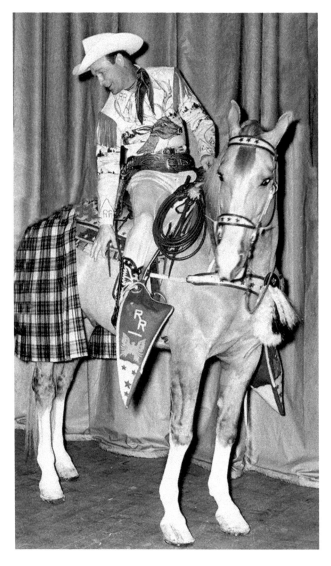

Roy Rogers and Trigger presented with a kilt in Glasgow.

In 2003 one Glaswegian recalled visiting the Kelvin Hall Circus thirty years earlier: 'I remember as a child being horrified by the chained elephant at the back of the Kelvin Hall and I have not been to a circus since then. I also remember being quite delighted when a lion peed on a school mate through the bars of its cage. We refused to travel home on the tram with him!' He was not the only person unhappy at seeing wild animals in circuses and public opinion began to question whether it was appropriate. In 2018 Scotland became the first country in the UK to ban the use of wild animals in circuses. Although wild animals such as lions and tigers can no longer perform, domestic animals still can. Zippo's Circus at Bellahouston Park in 2016 included performing cats: 'With his action hero cape billowing behind him, Felix, a seven-year-old moggy, is the undisputed star of a troupe of French acrocats that captivate audiences.'

Performing cat.

6. Glasgow's Zoos

The term 'zoo' was first used as an abbreviation by the London Zoological Society. In 1828 when London Zoo opened there already were a number of menageries in the city, but these were commercial attractions whereas London Zoo was created to enable the scientific study of animals. Glasgow's various 'zoos' before 1945 were essentially commercial static menageries.

Although the advert in 1840 for the city's first zoo claimed it would be on the 'same splendid scale as exhibited in the Zoological Gardens of London', the reality was somewhat different. The advert was placed by Thomas Atkins, who seven years earlier had opened a zoo in Liverpool and also assisted with the opening of Edinburgh's first zoo. However, what Atkins developed on a 3-acre site at Cranston Hill was essentially a pleasure garden with a menagerie as one of the attractions. The animals were brought by Atkins from his Liverpool Zoo and also displayed were some alpaca that had been brought to Scotland to

London Zoo and pleasure gardens, c. 1830.

promote the idea of breeding alpaca for their wool. The zoo clearly was not a success as it closed after just one summer.

The zoo that Atkins helped establish in Edinburgh, also a combination of pleasure grounds and a static menagerie, was more successful and, perhaps in light of Edinburgh Zoo's success, in 1844 the Glasgow Zoological Institution was established with the aim of creating a zoo along the lines of the London Zoo. To fund the project the society advertised for sale 2,000 £10 shares and began discussions about housing the zoo in part of the newly opened Botanic Gardens. However, insufficient shares were sold and the idea lapsed.

Although the notion of a city zoo was raised periodically in the press throughout the rest of the century, no firm plans emerged. In 1894 the *Glasgow Evening Post* asked Edward Henry Bostock, the owner of Bostock and Wombwell's Menagerie for his view on the idea of a city zoo:

> Mr Bostock said that he had often wondered why Glasgow and, in fact, Scotland, should be without a zoo. On the whole, Glasgow he thought would be a very suitable place for such a collection. The people had always shown great interest in the animals, and the supply of food stuffs was far better than in most towns. The chief difficulty would be the choosing of a suitable site, after which the rest of the business would be comparatively easy. For beginning, say, £10,000 would provide a very nice little show of animals, which would of a most interesting and instructive character. The prices of animals are high, but a good manager could often pick up bargains and work the place very economically.

Perhaps it was this discussion that prompted Bostock to open The Scottish Zoo and Variety Circus in New City Road in 1897. In spite of the name this was a permanent commercial menagerie rather than a zoo as we understand the term today. It was a decade later that the German Carl Hagenbeck created what is now regarded as the first modern zoo by introducing animal enclosures without bars and modelled as closely as possible to animals' natural habitats. Edinburgh Zoo, opened in 1913, followed Hagenbeck's ideas.

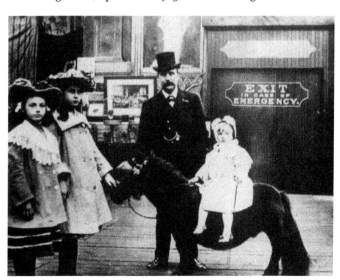

Edward Bostock with his three daughters in his Glasgow Zoo, 1903.

Yet Bostock's interest in animals was not wholly as a commercial showman. He was a member of a number of various zoological societies, and keen to interest the public in animals and natural history. Within the restriction of his building he exhibited as an impressive range of animals as most British zoos of the time: 'The magnificent collection of beasts, birds, and reptiles, including the two largest boa constrictors ever brought to Europe, are the talk and admiration of this city.' And new species were added within the first year:

Yesterday a case arrived from America containing a number of crocodiles and snapping turtles. Among these crocodiles there is one large specimen 11 feet in length. In the bird department there have been added some splendid African ostriches, rheas from America, emus from Australia, and an Asiatic cassowary in fine plumage. Another arrival from Australia is a wombat, an animal seldom seen in collections in Scotland.

For a number of years Bostock lent animals to Glasgow School of Art as one of the art professors explained:

Elephants, camels, zebras and other of the mammalia, have been brought to the School twice weekly for the use of the Animal Class to study animals whose forms and traits would otherwise have been possibly only seen in a book and photographs. We have not yet essayed the Lion, but the Camel has humped its way into the School, as we have also Yaks, Reeky Mountain Sheep and other strange creations.

In 2012, the artist Rosie O'Grady introduced a camel called Kokoso into the GSA building as part of her art work *Camellemac* inspired by these earlier animal visits.

Bostock also offered the bodies of animals that had died to Kelvingrove Museum to be preserved and added to its natural history collection. One of the most famous was the elephant Sir Roger. He had travelled the country over many years in Bostock's touring menageries but in 1897 moved to live at the Scottish Zoo. In 1900 the elephant began to suffer from musth, a painful condition experienced by many mature male elephants, and this led the animal to display unpredictable and aggressive behaviour. Sir Roger injured various keepers and eventually would not allow anyone near him, so that his food had to be thrown to him and his drinking water put down when he was not looking. Sir Roger's menacing attitude to visitors was also giving cause for concern, so Bostock reluctantly decided to destroy him humanely. In December a small party of soldiers shot Sir Roger, killing him instantly. His body was preserved by the taxidermy firm of Charles Kirk & Company in Sauchiehall Street and they had to remove their shopfront in order to get the elephant's body out when they were finished. Sir Percy remains one of the most popular exhibits at Kelvingrove Museum and if one looks closely, it is possible to spot some of the bullet holes.

A number of the animals displayed in Bostock's menagerie, including lions, also appeared in the circus that was presented in part of the Scottish Zoo building:

The circus includes varied entertainment, which nightly attracts a large number of spectators. Feats on horseback by a lady jockey, performances on the trapeze by a trio

Above: Camel in Glasgow School of Art as part of Rosie Grady's project in 2012. (Photo courtesy of the artist)

Right: Kelvingrove Museum poster featuring Sir Peter.

64

of juvenile athletes, and a comic exhibition by a troupe of dogs, are among the chief attractions. The animal performances, which are given at intervals during the day, are greatly appreciated, as they are instructive as well as being interesting.

In 1909 Bostock decided to sell a large number of his animals. Glasgow had recently been gifted Rouken Glen, a few miles south of the city, and Bostock proposed that the city build a zoo there. Having recently been elected a Glasgow Town Councillor Bostock offered to sell the animals to the city at a discount. The council declined his offer and the animals were auctioned in April 1909. The sale that took place in the Scottish Zoo premises was entrusted to the Glasgow auctioneers Dixon & Wallace, a firm more used to selling horses than exotic animals. Before the auction began a parade of the elephants, camels, and dromedaries took place, and Captain Rowley, 'the grey-haired, intrepid lion-tamer, put the lions and leopards through their paces to show buyers what they could do':

> It was a noteworthy sale, not only in the character of the stock but the buyers. They came from Austria and Germany, as well as all parts of Britain. then the auctioneer started

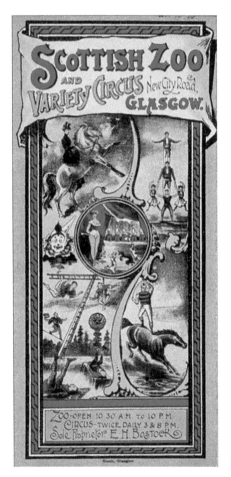

Poster for Bostock's Scottish Zoo in Glasgow.

his labours. At the sale the 'Gin Gin' triumphed over the elephant. The Gin Gin is an Australian bird, and notwithstanding the suggestion of an imprudent thirst which lurks in its name, it is a bird of blameless reputation. The elephant was the most impressive creature in the collection and the Gin Gin the tiniest. But it beat the bulky one by five guineas. Strangely enough this gentle bird was bought for 255 guineas by the renowned prize-fighter, Bob Fitzsimmons ... There was spirited bidding for the Boxing kangaroo but our 'ancestors' brought only trifling prices, including a chimpanzee although described as 'being a source of endless amusement'. The lioness 'Nellie' and the fox terrier, Caesar, who have been reared together since birth and sold as a pair, did well.

Bostock still owned many animals as he had at least three menageries on the road while others performed in the circus that continued to be presented at New City Road. The circus animals included 120 horses, ponies, elephants and lions. On 15 April 1910, 6,000 people crammed into the Scottish Zoo and Circus to witness the marriage of Alexander Gaston and Mary Mackie, the first wedding in Europe conducted inside a lions' cage. However, over the following year, circus attendances fell, perhaps as there were far fewer animals for spectators to view, and Bostock transferred his animals to London's Crystal Palace where they were one of the attractions at the Festival of Empire. 'In six days the doors of the Scottish Zoo will be finally closed, and once again Scotland will be without a

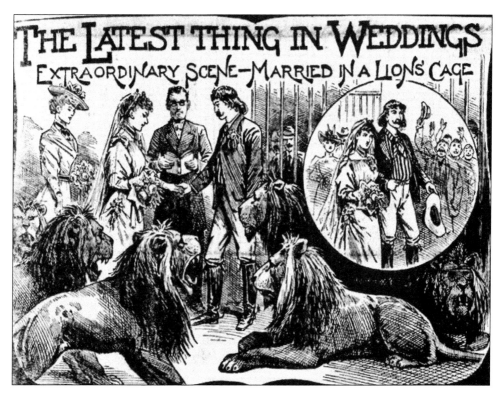

Married in the lions' den.

zoological collection,' the newspapers bemoaned in 1911. For the next few years the main use of the New City Road building was over the Christmas season when a 'Carnival and Fun City' was presented.

The opening of Edinburgh Zoo in 1913 prompted Glasgow council to reconsider the idea of establishing a Glasgow Zoo at Rouken Glen. Bostock presented the city with a pair of Indian Zebu cattle to get the project underway and these were kept in one of the stables at Rouken Glen while plans were taken forward. The Communist activist John McLean objected: 'Glasgow, having decided that cottages are too good for toiling masses, has now agreed to have airy residences for monkeys and other blue-blooded animals at Rouken Glen.' However it was not such objections that scuppered the plan. On 4 August 1914 the Zoo Committee's visit to Rouken Glen to finalise the project's start unfortunately coincided with Britain's declaration of war on Germany and the First World War put an end to the scheme.

A few days later Bostock's New City Road premises were commandeered by the military as a billeting centre, as Edward Bostock described:

> I was informed that no more than 1,100 men would sleep there a night. The first 500 arrived that night having been flooded out of tents at Girvan and slept in the Zoo building – they had nothing to sleep on, but bare boards, I persuaded them that there should be something more comfortable and was instructed to make paillasses and procure straw to stuff them. It was agreed that I would charge 3d per man per and it was I who had to count them each night. After several months acting as a lodging-house keeper, I am pleased to report that the mobilisation is now complete and my Zoo buildings in Glasgow have been cleared of sleeping soldiers and have instead been commandeered by the military as a storage place for aeroplanes which are packed into large cases.

Bostock's three sons all joined the army, as did around sixty of the men who worked for him in his various enterprises. This included his foreman who had been with the show for twenty-seven years and was the main trainer of the animals. In 1917, desperate to find somewhere to house the animals in his menagerie that had returned after their tour, Bostock finally managed to have the aeroplanes removed. The animals were moved in and Bostock relaunched his Scottish Zoo in one half and introduced roller skating in the other. The animals on display included a pelican that had been with the menagerie for over sixty years. Wounded soldiers and sailors were admitted free of charge. However, the hippopotamus that had been wheeled about the country, and the first to have been exhibited in Scotland, was sold to Manchester Zoo as it had twice outgrown Bostock's specially built wagons.

In 1920 Bostock leased the New City Road operation to his son-in-law. The zoo element was retained but one half housed summer concerts and a 'Carnival and Fun City' over the Christmas holiday season. In 1921 the carnival moved to Kelvin Hall as the Bostocks were contracted to provide a combined Menagerie and Circus there. By 1923, when Bostock decided to retire he controlled ten menageries, the Royal Italian Circus, and twenty theatres and cinemas. Although family members were involved in running the theatres

no one was prepared to take on managing the menageries, so again Bostock offered all his animals to the city at a greatly reduced price. Once more some protested at the idea of a Glasgow Zoo, including a correspondent to the *Glasgow Herald*:

> It is only natural that Mr Bostock should urge a zoo upon Glasgow people; he has had a life-long business association with zoos. Whether the Glasgow public desire to gloat at wild animals cribbed and confined behind bars is quite another matter. The idea that one can be taught natural history by cruelly confining wild animals has long since been abandoned; we have the cinema showing the animals moving happily in their natural haunts.

Yet again Glasgow Council declined the offer and Bostock's animals were sold to London Zoo.

In the 1930s a young Glasgow lad, Edward Campbell, befriended Andrew Wilson who owned a pet shop in Argyll Street called 'The Glasgow Zoo'. Campbell proposed that Wilson open a permanent menagerie and the pet shop owner took forward the idea. A derelict church in Oswald Street was leased and converted, with animals in cages on

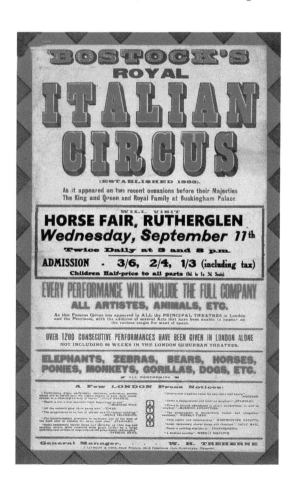

Bostock's Royal Italian Circus poster, *c.* 1920.

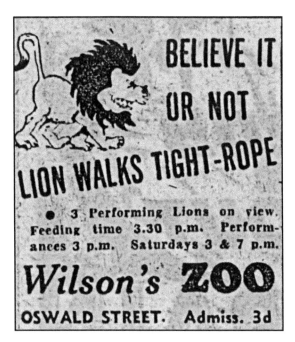

Advert for Andrew Wilson's Zoo.

two floors and a pet shop in the basement. Wilson expanded his business, becoming an importer and dealer in exotic animals. Campbell had the ambition to become a lion tamer and suggested that a lion act could be a big draw at what was now named Wilson's Zoo. So Wilson bought a couple of young lionesses for £15. To help train the lionesses, and teach Campbell lion-taming skills, the services of John Clarke were sought. Clarke was an ex-MP, City Councillor, journalist and expert lion tamer, having trained in a circus when young. One of the lionesses, Nurma was trained to master the difficult feat of walking a double tightrope 16 feet long. Campbell was now a skilled animal trainer and another young Glaswegian, Alexander Kerr, also set his sights on becoming a lion tamer. While working at Wilson's, one of his jobs being to polish the shells of Wilson's stock of 200 tortoises, he was taught by Campbell, and went on to become the star wild animal trainer for Bertram Mills Circus. The Wilson's Zoo lion tightrope act was hugely popular and although originally designed as a free draw to the pet shop, Wilson began to charge 3d entry. A small number of other animals were exhibited including a bear that was trained to do tricks with the lions, a black panther, monkeys, a badger, and a mynah bird that cried out 'Waur's the sawdust man?' in a broad Glaswegian accent.

Through his time training wild animals Campbell came to believe that the relationship between animals and humans often drew on extraordinary abilities in animals and cited many examples. One took place in 1941 when Campbell, who had been away on military service for six months, returned on leave and went to Oswald Street to see his lions:

Before entering I looked through a small spy-hole the staff used to keep an eye on customers. As I looked I saw the three lions suddenly stop pacing and intently fix their gaze on the closed door. After a minute or so they then started rushing about in

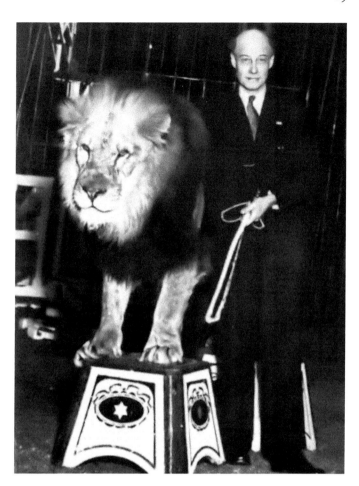

John S. Clarke – MP,
journalist and lion tamer.

a complete frenzy. I opened the door and entered the space, which contained around a hundred and fifty spectators. Instantly the lions crouched down scanning the room. When they saw me, they again leapt and bounded about and when I entered the cage they rushed to me and rolled about, insisting on having their tummies rubbed.

In July 1944 fire broke out in the building in the middle of the night. As Campbell was abroad fighting with the British Army, Wilson urgently phoned John Clarke who rushed to the scene:

Mr. John S. Clarke, ex-M.P., author, big-game hunter, animal tamer and Glasgow town councillor, crept into the cage of a fear-crazed lion and two lionesses - evaded their blind efforts to claw him - and applied a healing ointment to their burnt eyes. Mr. Clarke tamed the lion and lionesses when they were cubs. 'They must have found it agonising,' he said, 'for there is nothing they fear more than fire. Rajah, the lion, and Nurma, one of the lionesses quietened almost at once, but Delia scorched about the eyes, leapt savagely around the cage.'

Although the lions and the bear survived, sixty of the 200 birds and animals were suffocated by the smoke. Undaunted, Wilson had the zoo up and running again, and Nurma continued to delight spectators with her tightrope walking. After the war ended Wilson and his zoologist son William shared an ambition to open an outdoor zoo and began looking for a possible site.

This was not the only zoo project being developed. In 1936 Edward Hindle, a Professor of Zoology at Glasgow University, and others founded a new Zoological Society of Glasgow. The society suggested that a Glasgow Zoo should form one of the attractions of the 1938 Empire Exhibition being held in Bellahouston Park but the organisers rejected the approach. Undaunted, in 1939 the society acquired the Easter Daldowie Estate in Calderpark and began work on developing a zoo there. Yet again war with Germany disrupted the plan, although this time the project was merely shelved for the duration of the war rather than being abandoned.

After the war was over work to create the zoo at Calderpark got underway: 'Under Army instructors, students began excavating a lions' den with the aid of explosives and a bear pit.' Alongside the work to create the enclosures, animals began to be collected. These included a Soay sheep from the island of St Kilda, a pair of lion cubs presented by Dublin Zoo, penguins, wallabies, and exotic pets, such as parrots, gifted by their owners and less exotic ones, such as guinea pigs, gifted by children. Calderpark Zoological Gardens opened to public in July 1947 with 160 animals on display. Over 100,000 people visited the zoo in the first three weeks, putting the city's tram service under enormous strain. The

Polar bear enclosure at Calderpark Zoo.

lions' accommodation also came under strain as in September four lion cubs were born to the zoo's two lions that had been lent by London Zoo.

Two years later the Wilsons opened their competing attraction at Craigend Castle and Estate. Their Craigend Zoo had 4,000 animals, reptiles and birds. The site included two lochs offering rowing and motor boats for hire, and a tearoom in the castle's public rooms. One of the zoo's main attractions was Charlie the Elephant who resided in the stables. He and his keeper, Singh Ibrahim, were inseparable and one day, when Ibrahim set off for a drink in a Milngavie pub Charlie followed, unseen. Ibrahim only became aware of the elephant's presence when it got stuck in the pub's door as it tried to enter the bar. Charlie had to be freed by the local fire brigade.

Around the same time Calderpark Zoo had an episode of an animal following its keeper but this one had a tragic conclusion. While Head Keeper John Duffy was cleaning out the cage of a tigress called Sheila, he suddenly became aware of the tigress padding towards him from the inner cage, the connecting door having been accidentally left

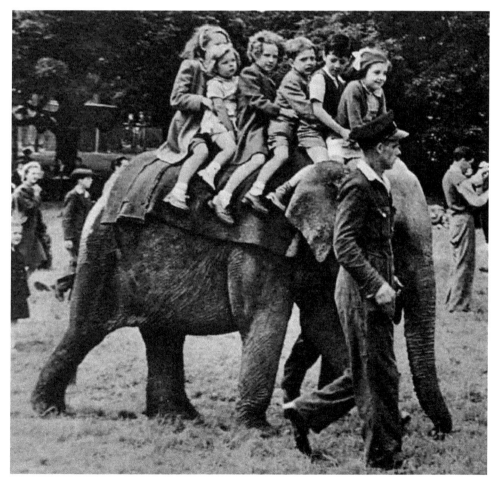

Elephant ride at Calderpark Zoo. (*Illustrated Sporting and Dramatic News*, 1948)

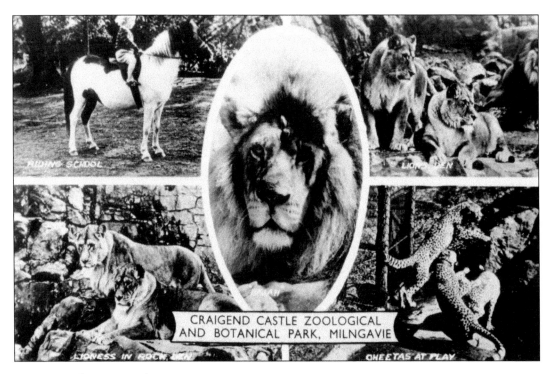

RIDING SCHOOL

LIONS DEN

CRAIGEND CASTLE ZOOLOGICAL
AND BOTANICAL PARK, MILNGAVIE

LIONESS IN ROCK DEN

CHEETAS AT PLAY

Craigend Zoo postcard.

unlocked. Sheila reared up and placed its paws on his shoulders. The terrified Duffy dropped to his knees and crawled between the tiger's legs, and escaped out the door. Unfortunately, Sheila followed and began to attack Duffy. Attracted by the keeper's cries for help, Alex Innes, the zoo gardener and an ex-policeman, rushed to his aid. Although all he had was a shovel, he beat the tigress around the head, distracting the animal from attacking Duffy further until others arrived with guns and shot the tiger. Duffy mercifully escaped with minor injuries. The unfortunate Sheila was stuffed and given to the Kelvingrove Museum.

Both Calderpark and Craigend zoos struggled financially in the early fifties. In 1955 the closure of the local bus service from Milngavie to Craigend resulted in a severe reduction in visitors and Craigend Zoo was forced to close. The estate later became part of Mugdock Country Park. The Wilsons also closed their Oswald Road zoo and moved the pet shop to Carlton Place. For a time it also looked as though Calderpark Zoo would close as a result of its perilous financial position but a generous donation from Herbert Ross, a Glasgow businessman, saved the day and other funding followed, enabling the zoo to thrive.

Many new developments were introduced at Calderpark Zoo over the following thirty years and around 130,000 people visited annually. A Tropical House was built that enabled snakes, lizards, crocodiles, alligators and other reptiles and amphibians to be housed in appropriate conditions. Glasgow and Lanarkshire Councils funded a 'Cat House' that allowed the public to view leopards, pumas, lynx and assorted wild cats on a more or less

Four lion cubs born at Calderpark Zoo in 1947.

nose-to-nose basis through glass panels. In 1988 a new £100,000 Himalayan Black Bear enclosure was opened by Johnny Morris, the presenter of the popular TV programme *Animal Magic*, and the project won the prestigious Zoo Animal Welfare Award, the first time the award had been bestowed in Scotland.

On Christmas day 1999 the zoo lay on a feast for its two prize turkeys, Snow White and Hilary. The zoo's director, Richard O'Grady, explained:

> I decided to give the two birds a treat as a mark of respect for the millions of turkeys on Britain's dinner tables that day. Our turkeys are a real attraction to all the visitors and it seems such a shame that all their brothers and sisters are being eaten. The funny thing is that they love cranberries and we have been given boxes of them. I'll also be giving them some corn on the cob, which they really enjoy. Snow White, an English White breed, nearly ended up as festive fare, two years ago. Bred to be eaten, she literally fell off the back of a lorry on her way to be killed. She was found by some animal lovers and I obtained her as a companion for Hilary.

Things were not so bright for Richard O'Grady that Christmas, however, as the threat of closure hung over the zoo due to mounting debts, decreasing levels of revenue and

public funding, and competition from the more successful Edinburgh Zoo. A plan to sell land for housing fell through and by 2002 the zoo was forced to sell some animals. The financial problems led to a decline in maintenance and staffing, and press reports began to circulate criticising unsatisfactory conditions. Animal welfare organisations were also critical and in August 2003 the zoo was closed with debts of £3.5 million. In the run-up to the closure, zoo staff in tandem with Scottish Society for Prevention of Cruelty to Animals worked to ensure all the animals were relocated to other zoos or enclosures. Since then, Glasgow has remained zoo-less.

In 1971 a young elephant arrived at Calderpark Zoo and was named Kirsty. For part of that time she was looked after by a keeper called Peter Adamson. Elephants are social animals and concern grew for lonely Kirsty. In 1987 she was given to Chester Zoo where she was housed with other elephants. In 2019 Peter Adamson decided to see if Kirsty was still alive and, if so, in which zoo she was housed. He tracked her down to Neunkirchen Zoo in Germany and arranged to visit. To his delighted surprise Kirsty instantly recognised him, even though it had been almost forty years since they had last been together.

Peter Adamson reunited with Kirsty in 2019.

7. Domestic Pets

The earliest information on dog ownership in Glasgow comes from the records of the dog tax that was introduced in 1797. In the city and the then separate burgh of Barony, ninety-six owners paid the tax. Owners of sporting or hunting dogs, such as greyhounds and spaniels, paid five shillings per dog, while owners of non-working dogs paid three shillings. (The weekly wage of a labourer at this time was around five shillings.) However, no doubt there were many who could not afford to pay the tax, or simply avoided the tax, although their dogs ran the risk of being caught and put down. Landowners were in favour of the tax as they believed it would reduce poaching by discouraging dog ownership amongst the poor, while others simply thought that poor people who could barely feed themselves should not keep a pet at all. Information on cat ownership in the past does not exist although certainly many would have been kept to control mice and rats, and some considered household pets.

Glaswegian chimney sweep with his pet dog, *c.* 1920.

Quality dogs were often stolen. In 1821 the dog belonging to John Adam, a spirit dealer, disappeared and he advertised at significant expense for its return, as many other owners of lost dogs did:

> Stolen or strayed. A Newfoundland dog, of the largest size, about eight months old, answers to the name of Caesar. Whoever has found the said dog is requested to return him to John Adam, 19 Bridgegate when they will be handsomely rewarded, but, if found in any person's custody, they will be prosecuted with the utmost rigour of the law. 19 January 1821.

In 1867 the Dog Tax was replaced by a Dog Licence, at an increased fee of 7s 6d. In 1912 Janet Bunten appeared in court charged with keeping a dog without a licence. She was Treasurer of the Glasgow Women's Suffragette League and the first to be charged for taking part in the suffragettes' non-payment of taxes campaign under the banner 'taxation without representation is tyranny'. She appeared in front of the Justice of the

1906 dog licence.

Peace, coincidentally called William Martin Peace, and it was reported that 'a touch of comedy was supplied by the fact that Mr Peace is a Suffragist and has taken the chair at a local meeting'. However Mr Peace's sympathies for the cause did not stop him finding Bunten guilty and as she refused to pay the fine she was jailed for ten days.

Payment of the dog licence was a problem for many during the First World War as husbands were away fighting or had been killed, so the Dogs Trust paid the dog licence fees of over 12,500 families. In response to a call for the licence to be raised to discourage the number of stray dogs in the city a writer calling himself 'Bow-Wow' wrote to the *Glasgow Herald*:

> Do your correspondents who write about the dog nuisance believe that the Almighty made a ridiculous mistake when he created these poor dumb animals, and that He made a misjudgement when he let Noah take two of them into the Ark. If Noah could tolerate a couple of them within the narrow confines of the Ark, not mention a whole menagerie of dirtier animals than dogs, surely your correspondents could tolerate dogs that don't belong to them.

Prize dogs at the Glasgow Dog Show in 1871. (*Illustrated London News*)

PRIZE DOGS AT THE NATIONAL DOG SHOW, GLASGOW

By the mid-nineteenth century dog and cat shows began to be organised. The first Glasgow Dog Show took place in 1864 and in 1871 the first national Scottish Dog Show was held in Burnbank Drill Hall in Great Western Road. It was organised by Martin Hendry, whose Glasgow business included taxidermy, the sale of foreign and British birds, ornamental cage making, and ostrich feather dressing:

> The dogs were arranged on raised benches which were so placed along the hall as to afford visitors every opportunity for a leisurely inspection of the different classes of animals. In the prick-eared Skye terriers, Mr Wilson, Glasgow, carried off the first and second prizes. His 'Spunkie', which stood first, has never been beaten. In the category, 'any other variety of pet dogs', the first prize was taken by a very tiny Pomeranian terrier, the property of Mrs A. Gardner.

Cat owners were not overlooked. In October of that same year Martin also organised the first Scottish cat show. The *North British Mail*'s report was extensive if somewhat flippant in parts:

> In these latter days everything is competitive from civil servants and barmaids to cats and canaries. The Cat Show held in the Burnbank Drill Hall is the first of its kind in Scotland which partly accounts for the limited response by owners of feline treasures.

Cat playing the bagpipes, *c.* 1890.

As a rule, the cats, either appalled by the novelty of their location or suffering from home-sickness, were remarkably depressed, having scarce energy for a mew or a hiss. In the heaviest cat category, ten gigantic cats betokened a brisk competition. The winner, a splendid grey and white Tom, tipped the scales at eighteen and a quarter pounds.

Many workplaces also have their pet dogs and cats. Two are commemorated in the city. The dog Wallace came to prominence in the 1890s. During a city parade in 1894 he became fascinated by the Glasgow Fire Brigade and followed the horse-drawn fire wagon back to the Central Fire Station. Although he was collected by his owner, Wallace kept returning to the fire station and eventually was given to the firemen as a mascot. When the fire brigade were called out, Wallace would run ahead of the fire wagon. He became a popular sight in the city and many believed the dog had special powers as he always seemed to know the way to the fire. The truth was that Wallace kept one eye on the driver who would use his whip to signal a right or left turn. One elderly lady, happening to notice that Wallace had a sore paw, made him four small rubber boots to help protect his paws on fire outings. However, Wallace only wore them once, losing two on the way to the fire. When Wallace died in 1902 the firemen paid to have their mascot stuffed and he resides today at the Scottish Fire and Rescue Service Heritage Trust Museum in Greenock.

In 1979 the People's Palace obtained a black-and-white cat called Smudge to deal with a rodent problem. This was a time of strong union membership in the city and an application was made for Smudge to have blue-collar membership of the National Association of Local Government Officers (NALGO), Glasgow chapter. NALGO did not

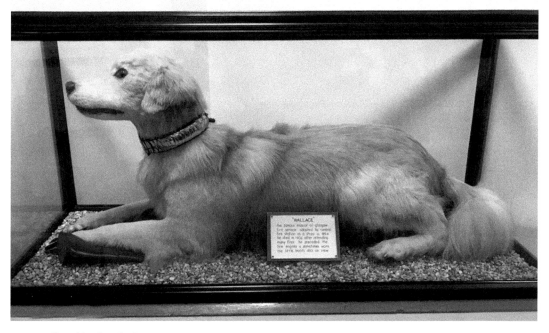

Wallace 'the fire dog'.

see the funny side of the request but the General, Municipal and Boilermakers Union did, and Smudge was admitted by it as a member with her own membership card. As a trade union member Smudge became the first recorded picket cat, making an appearance during a 1989 strike at Kelvingrove Art Gallery. Earlier, in 1987, Smudge went missing and many wondered if her disappearance was linked to the nearby celebration of the 70th anniversary of the Russian Revolution. To everyone's relief, Smudge reappeared three weeks later and over the following years headed up various campaigns, including 'Save the Glasgow Vet School'. In 1990 when Glasgow was chosen as European City of Culture that year, Smudge was proclaimed Glasgow's 'Kitty of Culture'. Smudge retired from public life in 1991 and a memorial plaque was placed at one of the entrances to the Winter Gardens.

Keeping birds has long been a popular pastime for Glaswegians. Cages of songbirds such as skylarks, goldfinches and linnets were commonly kept and in the seventeenth century canaries and other foreign species began to be imported. In 1853 a sale of exotic

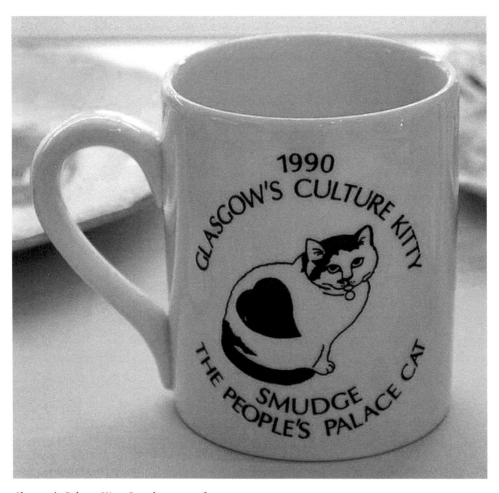

Glasgow's Culture Kitty Smudge – mug from 1990.

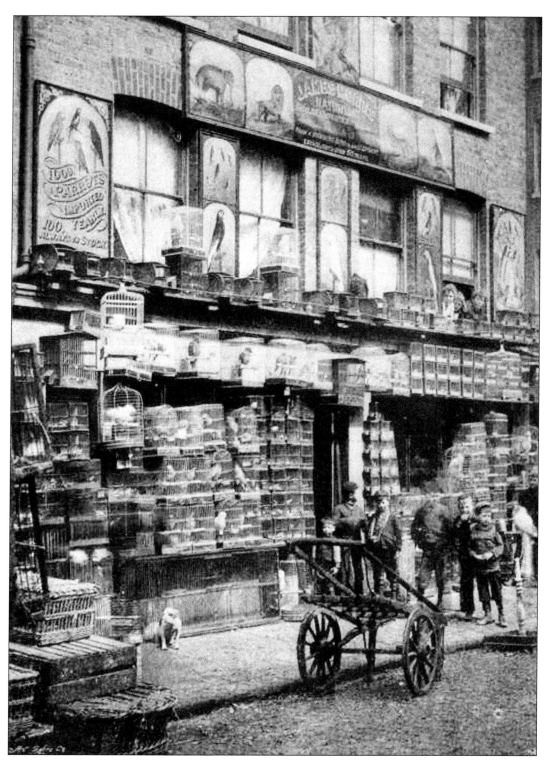

Pet shop with caged birds, *c.* 1900.

poultry was held in the Black Bull Hall in Virginia Street and 'from the moment the doors were open a stream of bird fanciers poured in'. The West of Scotland Ornithological Association's first Annual Grand Exhibition took place in 1859 in the Trades Hall in Glassford Street: 'The Association wish to induce fanciers throughout Great Britain to take advantage of this opportunity of exhibiting their specimens and have spared no expense to make the most perfect arrangements for the care and security of all birds.'

In the latter half of the nineteenth century the sport of pigeon racing grew in popularity, particularly among the working class, and pigeon fanciers who lived in Glasgow's tenements often attached small window boxes outside as lofts. In the Second World War a homing pigeon named *White Vision*, bred in Motherwell by the Fleming Brothers, was loaned to the National Pigeon Service of the British Army and in October 1943 the bird saved eleven crewmen on a Catalina flying boat. The plane had been forced to ditch in the sea and its radio was dead. So White Vision was released and flew 60 miles to land in appalling weather with details of where the plane was situated. The brave pigeon was one of twenty-nine pigeons awarded the Dickin Medal – the animal Victoria Cross. Although less common today, racing pigeons and breeding pigeons are still kept.

Pigeon fanciers, 1928.

A different form of pigeon fanciers are the Glasgow doomen that were featured in a 2010 article in *Scotland on Sunday*:

> A doo man arranges his pigeons in pairs – a doo and a hen – and they spend Monday to Thursday enjoying intimate companionship. He separates them on the weekend and sends his still horny pigeon out into the sky. A nearby doo man, seeing this, will send up a hen. The idea is that the birds mate and each will then attempt to bring the other back to its doocot. The birds that evade capture for years, capturing other pigeons all the while, become hated and coveted in their particular communities, loved only by their owners. One man says he used to keep his pigeons on his window-sill in Barlinnie Prison.

Talking birds have long been a favourite and many are tutored in Glaswegian humour. At a 1940 bird show in the city the prize for 'topical talks' went to 'wee Sammy Campbell' whose bird uttered 'Gie wee Sammy a gun tae shoot Hitler'. In his book *Glasgow Crimefighter*, the ex-detective Les Brown recalls another speaking bird he came across in the 1960s:

> A valuable parrot had been stolen from Edinburgh Zoo and suspicion had fallen on a school party from Castlemilk in Glasgow. The law descended on the school and we told the kids that all we wanted was the parrot to be given back and there would be no arrests and no one would go to court. A couple of nights later, a call came in tipping us off that the parrot would be found at an address in Ardencraig Road. There it was, in a large cardboard box, taped up and with suitable ventilation holes. The zookeeper came through to Craigie Street for a reunion and told us that the parrot would recognise him immediately and respond with a greeting. We opened the box and, before the keeper could speak, the parrot beat him to it, squawking, 'The polis are a shower of bastards!' loud and clear. It took the zoo folk six weeks to erase what the Castlemilk lads had taken two days to teach the parrot.

In the summer of 1939, with the threat of war looming, the National Air Raid Precautions Animals Committee issued the pamphlet *Advice to Animal Owners*. 'If at all possible, send or take your household animals into the country in advance of an emergency ... If you cannot place them in the care of neighbours, it really is kindest to have them destroyed.' Vets and animal protection organisations were incensed, but in spite of appeals to owners not to put down their pets, within one week of Britain declaring war on Germany, around 400 cats and dogs in Glasgow had been destroyed. 'We have had to deal with dogs of all shapes and sizes and every kind of breed from the little mongrel to the prize show dog,' said an official. 'Ten valuable greyhounds, collectively valued at £100, have been among those destroyed. People should give their pets a chance. They probably stand as much chance as a human being in an air raid.'

Sadly, many of the animals that remained in Glasgow were injured or adversely affected by the loud noises from the bombing raids. During two nights in March 1941 German bombers heavily bombed Glasgow in what became known as the Clydebank Blitz. Around

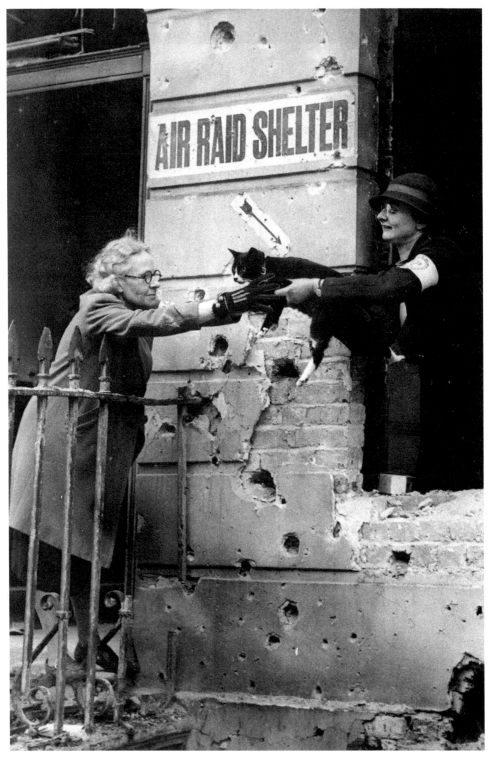

Cat rescue in the Blitz.

650 people were killed and many more injured, and a large number of homes destroyed or seriously damaged. One eyewitness account recalled looking into the street from her place of shelter: 'Canaries and budgies were flying about and a number of dogs raced past in panic. Their poor paws would be cut to ribbons.' Another recounted the aftermath when people were being evacuated out of the damaged areas: 'The most pathetic sight that comes to mind was that of family pets – cats, dogs and birds – all having been rescued by their owners, or left tied to the church railings because they were not allowed on the buses.' Later men were issued with rifles to shoot the stray cats and dogs, many of which were injured. A few caged birds were luckier. 'On the mornings after the raids a not uncommon sight was a homeless family with one of them carrying a canary or budgerigar in a cage, the small bird still bravely singing.'

It is not unknown for Glaswegian drinkers to treat their dogs when taken with them to the pub but one pet in 1849 perhaps was overindulged:

A pet sheep, named Tom, well known in the Saltmarket was accustomed to follow his master into the beer-shop, where he learned the first lesson of inebriety. Being coaxed, for the amusement of the company, to taste biscuit soaked in whisky, he soon improved, and became degrees a genuine tippler. While Tom was in his cups be was quite social, his greatest peculiarity was his epicurean fancies. He relished sweetmeats, would drink tea, chew tobacco, and was fond of oranges, and well known to the dealers in that commodity.

Tennent's Lager advert, 1909.

8. Animal Portraits

Animals feature in a number of Glasgow's public artworks and in recent times one equestrian statue has become the city's most recognised monument. In 2011 the statue of the Duke of Wellington astride his horse, Copenhagen, in Royal Exchange Square gained the dubious honour of being included in a list of the top ten most bizarre monuments on Earth selected by the travel guide *Lonely Planet*. However, it is not the actual statue that has won this accolade, but rather the local 'ritual', dating from the 1980s, of people plonking a traffic cone on the duke's head. Many have deplored the mischievous defacement of this significant public monument but in spite of the council's attempts to end the practice, every time a cone is removed it is only a matter of days before a new one appears in its place. Fortunately, Copenhagen has escaped a similar indignity.

Controversy about Wellington's equestrian statue is not new. Although the duke, who lived from 1769 to 1852, was a famous soldier and politician, serving twice as prime minister, he never once set foot in Scotland, so when the idea of a statue in his honour was proposed around 1840, some asked why. Even after the city decided to commission

Duke of Wellington statue, Royal Exchange Square. (Author)

Plaque on Duke of Wellington statue showing working horses. (Author)

a statue there was fierce debate about which artist should be given the commission. A committee of twenty worthies considered the issue and by a small majority awarded it to Baron Pietro Carlo Giovanni Battista Marochetti, a celebrated Italian-born French sculptor. The literary journal *Fraser's Magazine* was not wholly convinced by the work when it was unveiled in 1844: 'Two things were required – a striking likeness and a noble equestrian statue. The likeness, it is true, was there, though the qualities which constitute a noble statue were found wanting.' In 1848 Marochetti was forced to flee to Britain during the French Revolution of 1848 and took up residence in London where he quickly endeared himself to the British royal family and aristocracy with his urbane personality and brilliant sculptural style. The bas reliefs around the base include horses in battle, working horses, and a sleeping cat and various dogs.

There is one monument in the city far more deserving to be included in any global list of bizarre monuments, for it is the only equestrian statue in the world in which the rider is mounted on a two-legged horse. This splendidly quirky statue in Woodlands Road designed by Tony Morrow and Nick Gillon celebrates the legendary Scottish cartoonist Bud Neill and his character Lobey Dosser, who sits atop his trusty two-legged steed, El Fideldo. Neill's Lobey Dosser cartoon strip was set in the Wild West, but one wholly populated by Glaswegian characters, and brilliantly celebrates the Glasgow vernacular and attitude.

Surprisingly, the city has another equestrian statue with an American Wild West theme. It portrays Colonel William (Buffalo Bill) Cody riding a bucking bronco and is located in a small public garden on the corner of Whitehall Street and Finlay Drive, north of Duke Street, the site where Cody presented his world famous Wild West show in 1891. The sculpture is a modified copy of the famous American sculpture *The Outlaw*, created by Frederic Remington in 1906.

Above: Statue of Lobey Dosser and the original cartoon character.

Left: Colonel William (Buffalo Bill) Cody statue.

Two typical equestrian statues are sited in George Square, both also by Baron Marochetti. One portrays Queen Victoria and the other her husband, Prince Albert. It was following their joint visit in August 1849 that the city decided a suitable memorial to the queen should be commissioned. This time the choice of Marochetti to undertake the commission was unanimous; harmony due to Prince Albert having advised the city that Marochetti was held in high regard by the Queen. Although the choice of sculptor was never in doubt, there was significant discussion about how the Queen should be shown. It had been agreed that it should portray Victoria sitting side-saddle on a horse – the first equestrian statue of a woman in Britain – and there was concern that her small stature and feminine figure might be dwarfed by the horse. The statue was erected in 1854 in the centre of St Vincent Place, a site chosen by Marochetti, and the unveiling included a grand parade of the city's worthies. It was much admired and the *Illustrated London News* pronounced it 'by far the finest statue of the Queen that has yet been produced'. The monument was moved to George Square in 1866 to sit alongside the equestrian monument to Prince Albert that was commissioned from Marochetti following Albert's death in 1861. The Queen so admired this statue that in 1888 she ordered a replica to be erected in Windsor Great Park.

The city's oldest equestrian statue portrays King William III – known colloquially in Glasgow as 'King Billy' – and depicts him in Roman military garb, a reference to a famous statue of Marcus Aurelius in Rome. The statue, whose maker is not known, was presented to the city in 1735 by James Macrae who made his fortune as the Governor of

Unveiling of Queen Victoria statue in 1854.

William III of Orange (King Billy) statue. (Author)

the Presidency of Madras before returning to Scotland. Macrae was a staunch Protestant and offered the statue to the city as a memorial of 'our glorious hero and deliverer (under God) from Popery and slavery'. In the 1890s it was considered an obstruction to traffic and so moved a short distance to a spot in front of the new Glasgow Cross railway station. In 1928, after a brief spell in storage, it was moved to Cathedral Square. Sadly, Glasgow's sectarianism has often led to the statue being damaged, most recently having its tail broken off.

In Kelvingrove Park Lord Frederick Sleigh Roberts sits mounted on Vonolel, his Arabian charger. Roberts became a national hero for his achievements in the colonial wars of India and Afghanistan, and in the Boer War in South Africa. Following his death in 1914 Glasgow decided to commission a statue in his honour and chose a duplicate of an existing statue of Lord Roberts that had been sculpted by Harry Bates for Calcutta in 1898. The Glasgow version was executed by Henry Poole and unveiled in 1916.

Representation of robins and fish can be seen throughout the city as these form part of Glasgow's coat of arms and refer to the city's patron saint, St Mungo, who is reputed to have restored a dead robin to life. Many of the vivid contemporary murals that can be found around the city feature animals, and a robin is included on a huge one painted on a gable end in the High Street by Sam Bates. Shona Kinloch's life-size *Chookie Burdies* can be found perched on top of lamp posts around the Garnethill area.

Given that Glasgow Green was the site of many of the menageries of the past it is appropriate that portrayed there on the Doulton Fountain opposite People's Palace are three unusual animals: a moose and a beaver, modelled by William Silver Frith, and an ostrich, modelled by Herbert Ellis. Designed by Arthur Edward Pearce, the highly

Glasgow's coat of arms. (Author)

Mural on gable end of High Street by Sam Bates. (Author)

decorative five-tier fountain was Doulton's main display piece for the 1888 International Exhibition in Glasgow's Kelvingrove Park and denotes Britain's significant dominions at that time: Canada, Australia, South Africa and India. Around the top are lions' heads and lion sculptures can be seen elsewhere in the city, two of the finest guarding the Cenotaph in George Square, symbolising the bravery and endurance of those who perished. The monument was created by Edwardian architect Sir John James Burnet, and unveiled in 1924. Another proud lion, resting its paw on a cannonball, stands atop Langside Battlefield

Moose and beaver modelled by William Silver Frith on Doulton Fountain. (Author)

Memorial on Langside Hill on the south side of Glasgow. This commemorates the site of the Battle of Langside – one of the most significant battles to take place in Glasgow – and the defeat of Mary, Queen of Scots in 1568. Somewhat incongruously it was erected in 1887 to coincide with the 300th anniversary of the queen's beheading. The memorial was designed by Alexander Skirving, and the lion and the eagles seated at its base were carved by James Young.

In Kelvingrove Park there is a handsome sculpture of a Bengal tigress bringing a dead peacock to its cubs. This is a cast of a sculpture made by Auguste-Nicolas Cain for the 1867 Paris Exhibition and was presented to the city by a merchant, John Kennedy. Another cast is sited in Central Park Zoo in New York.

A cockerel has graced Glasgow Cathedral's spire since at least the fifteenth century, although the bird has had to be replaced from time to time as its lofty position has made it prey to gales. Although the current one survived a gale in 2011, it had to have its tail restored. It is thought that the representation of a cockerel on church weathervanes stems from the sixth century when Pope Gregory I declared that the cock was the animal most worthy of signifying Christianity as it symbolised Jesus' prophecy that the cock would not crow in the morning until Peter denounced Him three times. Another fine example can be seen on top of the Tolbooth Steeple. While the cathedral's gargoyles are ferocious animal heads, a dragon portrayed on the exterior wall appears quite playful.

Tigress statue by Auguste-Nicolas Cain in Kelvingrove Park. (Author)

Right: Cockerel on Glasgow Cathedral steeple. (Author)

Below: Dragon on exterior of Glasgow Cathedral. (Author)

On the Wellington Street façade of the Commercial Bank of Scotland, 30 Bothwell Street, are four bas-relief panels, *The Qualities of Man in Modern Society*, sculpted by Joseph Armitage in 1934. One includes a ram with impressive horns and another, an ox. Andy Scott, who created the popular Kelpies in Falkirk, has created two animal works in the city: a Highland cow sited at the Children's Farm in Tollcross Park, and a horse sculpture in Lochgoin Avenue, Drumchapel, drawing its inspiration from the Gaelic meaning of Drumchapel: 'ridge of the horse'.

Kenny Hunter's 1999 work *The Calf*, in Graham Square off Gallowgate, marks the site of the old meat market and he also created the 2019 work *The Elephant* in Bellahouston Park, the location for Glasgow's 1938 Empire Exhibition. Hunter's life-size sculpture of an Indian elephant was cast using scrap sections of trains that were originally built in Glasgow and exported to the Commonwealth. An elephant was chosen as the animal has a direct connection to the countries where many of the trains were deployed, such as India, Pakistan, Kenya and South Africa – either as a form of transport or a creature of symbolic power.

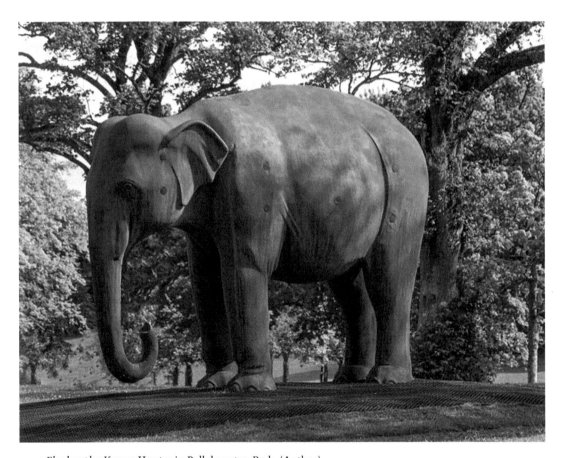

Elephant by Kenny Hunter in Bellahouston Park. (Author)